DID I DO THAT?

THE BEST (AND WORST)

of the '90s

TOYS, GAMES, SHOWS, AND OTHER STUFF

DID I DO THAT?

THE BEST (AND WORST) OF THE '90s

TOYS, GAMES, SHOWS, AND ~~OTHER STUFF~~

By Amber Humphrey

ABRAMS IMAGE
New York

CONTENTS

INTRODUCTION

The twentysomethings in the 1994 romantic comedy *Reality Bites* embodied the "Generation X" slacker ethos that, for a lot of people, defined the decade. When the movie was released, I, like Ethan Hawke's character, was a jobless deadbeat. What's more, I mooched off my mother unapologetically. But then, I was eleven years old. I also couldn't have cared less about *Reality Bites*—a movie that I only saw for the first time three years ago. Neither Kenan Thompson nor Kel Mitchell was in it, so what was the point?

It's true, in the '90s, Nirvana was big; people were drinking Zima and wearing flannel; "boys" was spelled with a "z" (see: Boyz II Men and *Boyz n the Hood*). But if you were chilling with your friends by the monkey bars when the decade began and prepping for prom when it ended, then Steve Urkel probably figured more prominently in your version of the '90s than Kurt Cobain. This book celebrates that.

What you'll find here is an exaltation of the decade's kid culture, a sampling of the things that those of us who came of age in the '90s thought were the bomb and that now, as adults, bond us. Our generation grew up during an era that saw an upsurge in social liberalization and a tremendous boom in technology.

Even though we weren't fully aware of this, the transformation was reflected in our toys—which were increasingly electronic—and television shows and movies, which, in many cases, were more irreverent and progressive than children's entertainment had been previously.

The toys, games, and shows in this book are ones that played a role in my own adolescent years, which means that some popular fads may have been left out and a few subjects that may seem like more obscure by-products of the era—as well as a handful of things that debuted in the '80s but peaked in the '90s—were included. The goal is to present the features of an authentic '90s childhood, not a description of the decade that you'd find if you Googled "the '90s," and the only way to do that was to write about what makes me nostalgic. At the same time, this isn't so personal that it's just *Widget, the World Watcher* fan fiction.

I hope that flipping through the pages will allow you to revel in the simplicity of childhood, and that the book serves as a temporary escape for any twenty- or thirtysomethings who are starting to deal with all of the overwhelming responsibility that comes with adulthood. Ideally, you would have bought this book in lieu of paying your utilities bill. Though if your bills set you back only as much as it would cost to buy a book, then you're doing something right.

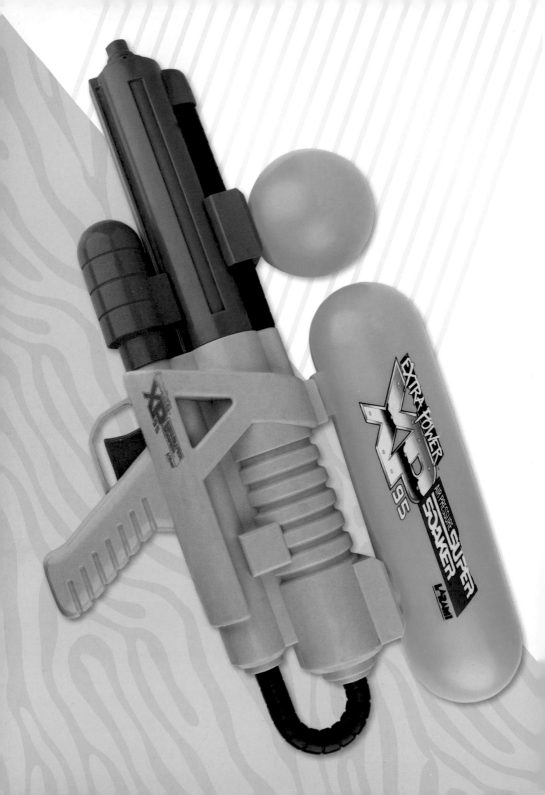

SUPER SOAKER

ou know that obnoxious, cocksure kid who—through charm or apparent coolness or just really dreamy eyes—conned you into handing over your expensive, awesome, new toy, and then held on to it for way too long, saying something like "Just let me play with it for one more minute" every time you meekly asked for a turn with this wonderful thing that you owned, that your parents bought for *you* and not this jerk? Well, I was the jerk with the dreamy eyes—not always, or even usually, but one day on a class trip to the local beach, that was me.

The Super Soaker XP 95 was part of a new generation of "extra powerful" Super Soakers that offered "twice the drench" of the original model. How exactly is drench measured? Only the brilliant scientists at Super Soaker headquarters know.

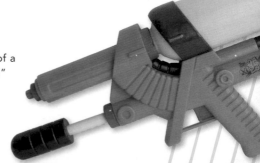

The bit of cutting-edge plastic that I so heartlessly held captive: the Super Soaker 100.

The worst thing is that I had a Super Soaker, one that was fully operational, and thoroughly fun to play with, but mine was a Super Soaker 50, and simple math will tell you that that's 50 percent less good than a Super Soaker 100. So I had to use this kid's. You'll never get any argument from me about the excellence of this air-pressured water gun, but it did kind of turn us into jerks. Maybe you didn't trick a friend into loaning you his or her Super Soaker, but if you owned one, I'm sure that at one point or another you were responsible for getting someone super soaked. You could have stopped at soaked, but no, you had to super soak 'em.

WETTER IS BETTER

Called "a squirt gun on steroids" by some, the original Super Soaker was released in 1991 by Larami Toys. Incorporated into the water blaster's bright yellow frame were one large green water tank and a pump on its barrel that created pressure. When you squeezed the trigger, all of that compressed water from the tank shot out of the nozzle, drenching and, most likely, pissing off your target (unless your target was a fence or something, in which case, your target was cool with it). Most hydro-weaponry scholars would probably say that the Super Soaker was to water warfare what automatic firearms were to actual warfare—they made battle a lot scarier. After that first Super Soaker debuted, a new model was unleashed every year—some had more water tanks than the ones that had come before them, others could shoot farther, but all were marvels of modern science.

While most commercials attempt to boost the appeal of a product by explaining that it's superior to the competitors, the commercial for the Super Soaker XP 55, released in 1995, proclaimed that this new addition to the XP

range "blasted twice as much water as other Super Soakers." Other Super Soakers! Naturally there were other water-gun brands during this period, but Super Soaker dominated the market. Instead of trying to outdo competitors, it seemed like Larami Toys was just trying to top itself. In the XP 55 commercial, all of the weenies in the matching cerulean sweater vests are shown holding ancient (read: four-year-old) Super Soakers, while the devil-may-care, no-holds-barred, 'bout it 'bout it kids with the flannel shirts and the backward baseball caps are toting XP 55s. This has to be the only commercial where a company implies that people who own their product are lame.

THE DECADE'S BEST INVENTION?

Guns aren't my thing, and I stay away from them for all of the obvious reasons—they're dangerous, they're scary, that episode of *Beverly Hills, 90210* where David's best friend Scott accidentally shoots himself really hit home, etc. Pre–Super Soaker, any sort of imaginary gunplay was usually just as uninviting to me—be it with toy guns or just fingers pointed to look like a gun. The Super Soaker changed that. We should all be proud of Lonnie Johnson, the former NASA engineer who invented the Super Soaker. He did a great service to his country by blowing off those NASA chumps and creating something important, something that completely changed our attitudes about what water guns could be.

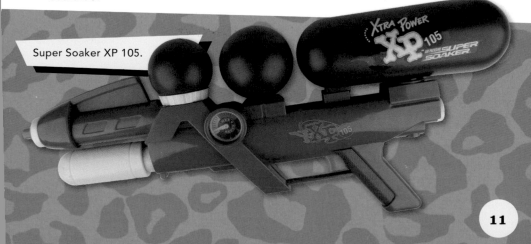

Super Soaker XP 105.

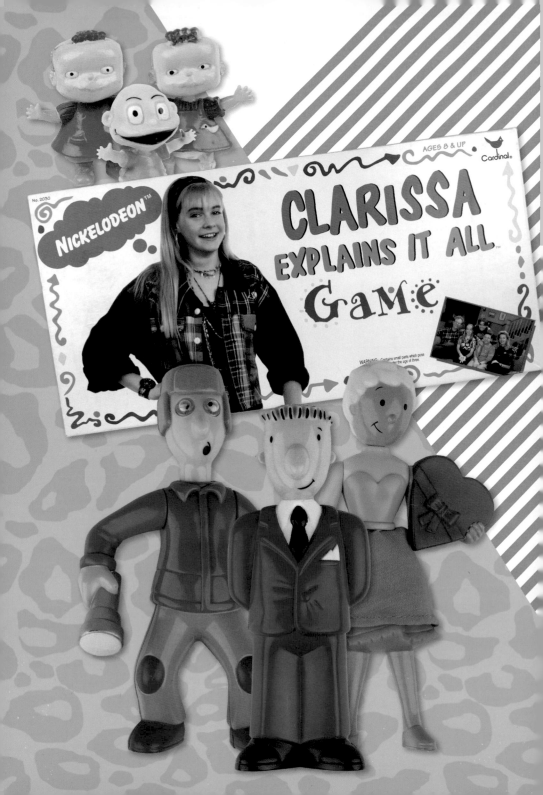

NICKELODEON

Nickelodeon was so much more than a cable TV network for kids. Preteen hopes and dreams were born while watching Nick. We yearned for lives like those of the people we saw on the shows, and because those people were kids as well, that dream felt as though it was within our grasp. When I was nine years old, my life goals were to scale the Aggro Crag as a contestant on the action sports game show *GUTS* and to wear spandex shorts underneath a pair of cutoffs like protohipster Clarissa Darling, the unflappable, fourth wall–breaking title character of the sitcom *Clarissa Explains It All*.

 Rugrats figurines, the *Clarissa Explains It All* board game, and *Doug* Happy Meal toys were just a few of the Nickelodeon TV series tie-in products that were released as the cable network's brand grew during the '90s.

NICK IS FOR KIDS

Before Nickelodeon, there wasn't a channel exclusively devoted to children's programming. But in 1979, a group of adults finally realized that kids want to spend all day, every day in front of the TV, and the network was launched. Early hits like *You Can't Do That on Television* (which introduced the green slime that became so crucial to the Nickelodeon brand) weren't produced in-house. It wasn't until the late-'80s premieres of *Out of Control*, a sketch comedy show hosted by Dave Coulier, and *Hey Dude*, a sitcom about a dude ranch staffed by teenagers, that series were created specifically for the channel. Nick's flagship cartoons debuted in 1991: *Doug*, *Rugrats*, and *The Ren and Stimpy Show*. They were all unconventional—*Doug* was about adolescent anxiety and, I think, premature balding; *Rugrats* featured babies using malapropisms; and *Ren and Stimpy* coupled gross-out humor with satire. These "Nicktoons," as they were called, set the tone for what was to come.

SNICK, which stood for Saturday night Nick, began in 1992. *Clarissa Explains It All*, *Ren and Stimpy*, *Roundhouse*, and *Are You Afraid of the Dark?* were the first four shows to air during the two-hour block. Later, *All That*, a sketch comedy show modeled after *Saturday Night Live* and *In Living Color*, joined the lineup. Its consciously multiethnic, all-kid cast did impressions of Ross Perot and Bill Cosby, parodied the Spice Girls, and created quotable characters like Ed the cashier ("Welcome to Good Burger, home of the Good Burger, may I take your *ooorder*"), who would eventually be the star of the cinematic tour de force that is *Good Burger*.

SNICK's tagline, "Prime-time Saturday Nights are yours," was meant to make kids realize how disenfranchised we were and that they were tending to our needs. Even if it was part of a marketing technique, it didn't

Chuckie from *Rugrats*.

Ren and Stimpy.

matter because they were right. There was nothing else for us to watch, or at least nothing that was specifically catering to us. In 1991, before SNICK, our Saturday night network TV options would have included *The Golden Girls* and *Empty Nest*—two shows that were literally about being old.

Novels based on Nick shows: *The Secret World of Alex Mack: Take a Hike* (1996) and *Hey Dude: Showdown at the Bar None* (1992).

Those of us who were lucky enough to have basic cable immersed ourselves in the network, so a large part of our worldview and what we wanted out of life was shaped by what we were seeing on TV. I wouldn't have ever been interested in going to summer camp if I hadn't watched *Salute Your Shorts*, a show set at "Camp Anawanna," where the kids weren't just there for the summer, but, it would seem, two years straight; or almost busted my face while trying to jump over my own leg if it hadn't been for the dancers on *Roundhouse*, who executed the move flawlessly.

The Nick brand grew to include *Nickelodeon Magazine* and novelizations of shows like *The Secret World of Alex Mack* and *Hey Dude*, which allowed us to delve even deeper into the lives of the characters that we loved. You might not have had the style acumen of Clarissa Darling, but you could play the *Clarissa Explains It All* board game—even if you didn't find it entertaining, at least you had a big box with the words "Clarissa Explains It All" on it.

The Adventures of Pete & Pete

Originally airing 1993–1996, *The Adventures of Pete & Pete* chronicled the surreal exploits of two red-haired brothers with the same name. Big Pete and little Pete Wrigley had their own personal superhero, Artie, the strongest man in the world (who may have had some mental-health issues), and their mother had a metal plate in her head that allowed her to pick up radio signals. Steve Buscemi and Iggy Pop lived in their neighborhood, LL Cool J was little Pete's teacher, and Michael Stipe was their local ice cream man. Big Pete was a dreamboat, not in the superficial *Tiger Beat* sense, but because he was sensitive and introspective. His little brother, on the other hand, was wild, stuck things up his nose, had a tattoo named Petunia, and looked like he probably smelled bad.

15

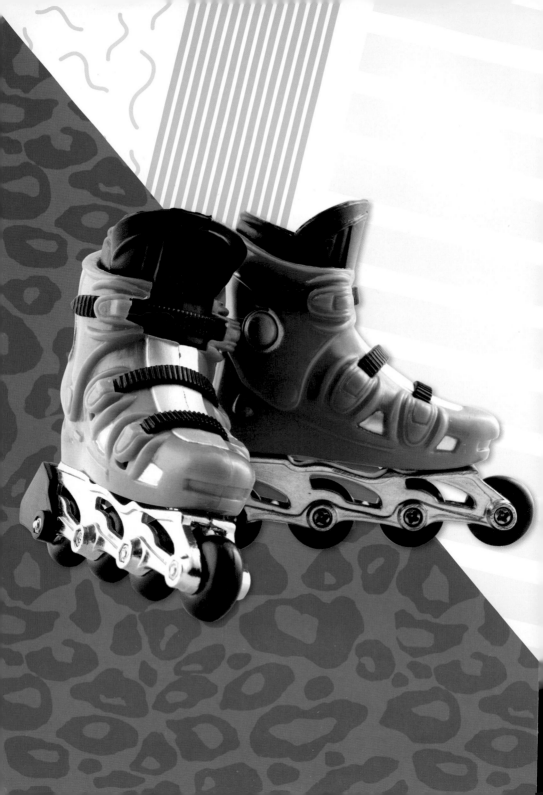

ROLLERBLADES

Rollerblade was a brand of inline skates, but none of us called our inline skates "inline skates." That would have been weird and made whomever you were talking to feel really uncomfortable. "Do you want to go inline skating later?" Ugh. It creeps me out just writing it. Calling your rollerblades—which is what they were—inline skates would have been like calling a generic Pop-Tart a toaster pastry. "Would you like to consume toaster pastries with me and then partake in an afternoon of inline skating?" No, I would not.

 Age ain't nothin' but a number. Rollerblades, or technically, "inline skates," had cross-generational appeal and were popular with adults and children.

Calling them "blades" was just as bad. It was too self-consciously cool, like you were trying too hard to show how down you were. "Blades" or "blading" were words used in SunnyD commercials or Disney movies about *rollerblades* and *rollerblading*. Can you imagine your grandmother buying you a pair of rollerblades as a gift and saying, "Sweetie, I got you those blades you've been wanting"? Uh, thank you?

GENERATION XTREME

The reason for the name: the wheels were arranged in a line as opposed to being set two-by-two like conventional roller skates. The first inline skates were used years before they gained popularity in the '90s, with some saying that the invention dates back to the eighteenth century. The Rollerblade brand was founded in the '80s, and by the mid-'90s only little girls were still using roller skates. Rollerblades were dangerous—you could seriously hurt yourself if you didn't know what you were doing, or even if you did know what you were doing—and that made them cool. If you saw someone roller-skating to school—even in the days before rollerblades—you would've thought, "What's up with this asshole?" But rollerblades were a socially acceptable mode of transportation.

They looked like ski boots with wheels and were usually black, although they made white ones that were worn exclusively by elementary school girls. There was a piece of rubber attached to the bottom of the heel called a

Nintendo's *Rollerblade Racer* (1993).

18

"brake," but I never used it. If I wanted to stop, I would run into a wall or fence. When there was no structure to halt my momentum, my "brake" was my faith in God. Nintendo's *Rollerblade Racer* (1993) captured the perils of the sport perfectly. In the game, you had to navigate through streets filled with cracks, which is really what the world seemed like in those days. If you rolled over a crack in the game or in real life, you were going to wipe out.

Rollerblading was both a recreational sport—enjoyed by tiny children, health nuts, and topless dudes at Venice Beach alike—and a competitive sport. National rollerblading competitions were being held as early as 1990, and the first X Games—then called the "Extreme Games"—included an inline skating event, along with skateboarding and bungee jumping.

Nothing looks cooler than safety.

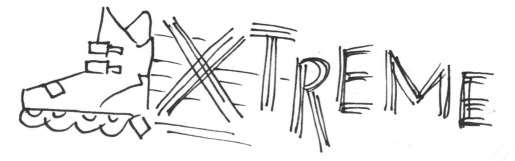

ROLLERBLADING FOR GIRLS

We were all rollerblading, so it only made sense that our dolls would want to get in on the fun as well. In 1991, Mattel's Rollerblade Barbie debuted. Her pink skates would "flicker 'n flash" when you rolled her across a hard surface. These dolls ended up being recalled as a fire hazard, but I'm sure they were fun to play with before they set your bedroom ablaze. Baby Rollerblade, a battery-powered doll that could really skate, was a step too far, in my opinion. Babies should not be rollerblading. These dolls speak to the strange dichotomy that existed during this time. Rollerblades were simultaneously very extreme, but also very accessible to people who wore pink.

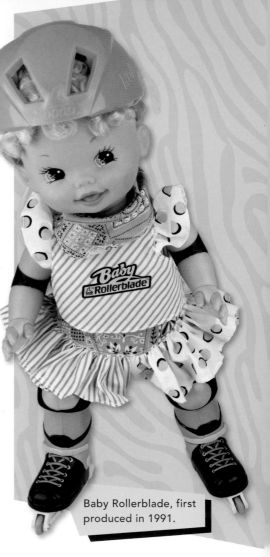

Baby Rollerblade, first produced in 1991.

NATURAL SELECTION

Rollerblading wasn't a fad. At least, it didn't seem like one. It felt like the next progression in skating technology. But I hardly ever see people rollerblading anymore, and when I do, they look just as out of place as they would if they'd been riding one of those penny-farthing bikes with the huge front wheel and small back wheel. Around the time that rollerblades were

becoming popular, interest in skateboarding was on the rise (this is when it became acceptable to substitute the "ex" in "extreme" with an "X"). Aggressive skateboarders and rollerbladers—the people you'd see grinding on handrails—were rivals. Being forced to share the same skating areas bred tension. The struggle between rollerbladers and skateboarders was like the struggle between two competing species fighting over limited resources in an ecosystem. Skateboarding is still popular, but rollerblading isn't: evolution in action.

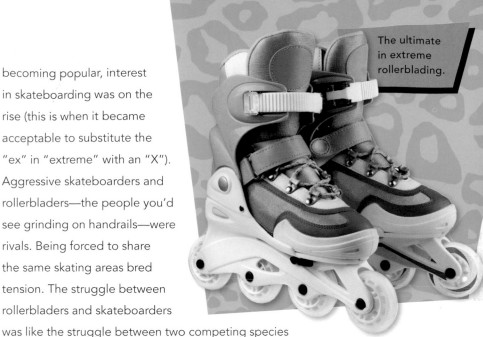

The ultimate in extreme rollerblading.

Airborne

Attempting to capitalize on our fascination with these newfangled skates, in 1993, Warner Bros. Pictures released *Airborne*—or as most people know it today, "that one movie about rollerblading." The cast included members of the national Team Rollerblade, a teenage Seth Green, and Jack Black in one of his earliest roles—fortunately, the two actors were able to escape being pigeonholed and have since worked outside of the rollerblade film genre. In the movie, Mitchell (Shane McDermott), a laid-back California kid whose ultimate goal in life is to be "stylin'," moves to Cincinnati, where he's forced to contend with snow, hostile jocks, and in the tale's thrilling conclusion, a rollerblade race down the quaintly named "Devil's Backbone." He ends up winning the respect of the jocks, getting kissed by a cute girl, and jumping off the roof of a parking garage without dying, all thanks to his sweet rollerblading skills.

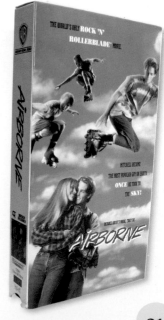

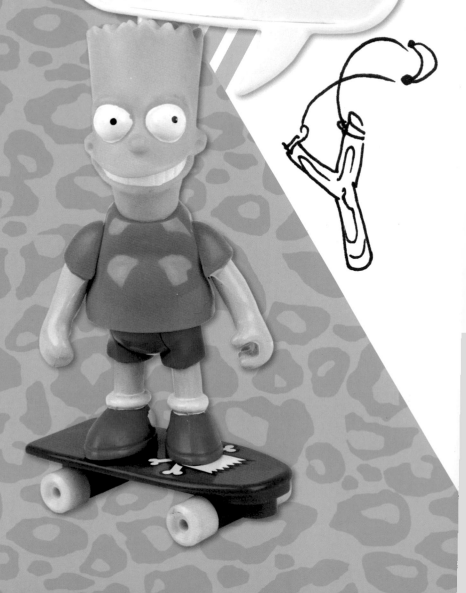

BART SIMPSON

Although *The Simpsons* wasn't necessarily intended for kids, Bart Simpson's defiant spirit and his unabashed hatred of school resonated with us. Bart would look an authority figure dead in the eye and say, "Eat my shorts," he'd prank call sad-sack bartender Moe and ask to speak to "Oliver Clothesoff," and he maintained a very lenient stance on the defacement of public property. Bart was a ten-year-old underachiever, a scamp of the highest order, the role model that no sane adult would ever want his or her child to have—and yet, our parents bought us *Bart Simpson's Guide to Life*, a book that extolled the virtues of hell.

 Mattel released the poseable Bart Simpson action figure in 1990. It came with five interchangeable word balloon cards and a custom skateboard.

I'M BART SIMPSON: WHO THE HELL ARE YOU?

Before becoming a social agitator and hero to people with spiky, skin-colored hair, Bart was one of the crudely drawn Simpsons characters on a series of animated shorts that aired during *The Tracey Ullman Show* in 1987–1989. The Simpsons—Homer, Marge, and their three children, Lisa, baby Maggie, and Bart—were a dysfunctional clan, and the shorts celebrated that. Bart (which is an anagram of "brat") was your typical unruly child, his mischievousness mostly limited to eating more cookies than he should and making silly faces. However, once the characters spun off into their own show, Bart's antics "embiggened" and he became the bad kid that all other fictional bad kids were measured against. In the first three seasons, Bart flushes a cherry bomb down a school toilet, tricks the entire town of Springfield into thinking that he's fallen down a well, and cheats at Scrabble!

By 1990, Bart was the most recognizable member of the Simpson family—the character that was synonymous with the show's subversive humor—and he had catchphrases galore. Aside from "Eat my shorts," there was "Don't have a cow, man" and "Ay, caramba." "I'm Bart Simpson: Who the hell are you?" was the one that I used most often because it provided me with the opportunity to say "hell." These catchphrases made their way onto Bart T-shirts, kick-starting "Bartmania," a phenomenon that led to the creation of a lot of Simpsons merchandise for kids, like Nintendo games and comic books.

THE BART SIMPSON DOLL

The Bart Simpson doll was vicious, straight up. The body was plush and snuggle-able. The head, however, was hard and plastic, topped with Bart's trademark pointy hair ridges, which are cool on the show but significantly less

The infamous, deadly-haired doll.

A Bart Simpson alarm clock.

cool when they're stabbing you in the face. The arms and hands were made of the same hard plastic and were good for a scratched cornea. To a certain extent, I'm to blame for some of the injuries that I suffered. For me, playing with the doll consisted of haphazardly swinging it by its arms and tucking it into bed with me at night—I was tempting fate. Bart was a troublemaker, so it does make sense that my relationship with the doll would have been so volatile.

BART'S LEGACY

The Simpsons has gone on to broadcast more than five hundred episodes, and while "Bartmania" may be over, Bart is still my favorite character. He was mischievous, not malicious. He had a conscience but was just helpless to control his impulses—that's relatable and it makes him likable.

I have a Simpsons tattoo on my back. It's the same one that Bart got on the show's first full episode: a heart with "Moth" scrolled across it (Marge bursts into the tattoo parlor and yanks him away before the "er" can be added to the end). That's there forever, and it's a testament to Bart Simpson's tremendous impact on our culture and my back.

Rufio and Bart Simpson: Brothers from Another Mother

Robin Williams, Dustin Hoffman, and Julia Roberts can all be found in Steven Spielberg's *Hook*—a 1991 sort-of sequel to *Peter Pan*. But the real breakout star of the movie? Rufio, Rufio, Ru-fi-ooo! Portrayed by Dante Basco, Rufio, the midriff-baring Lost Boy who ran Neverland while Peter Pan was busy growing into a hairy, middle-aged comedian, has a lot in common with Bart Simpson. Spiky hair? Check. Rebellious individualism? Check. Forever young? Check (Rufio peaced out at the end of the movie, but still, technically, forever young).

25

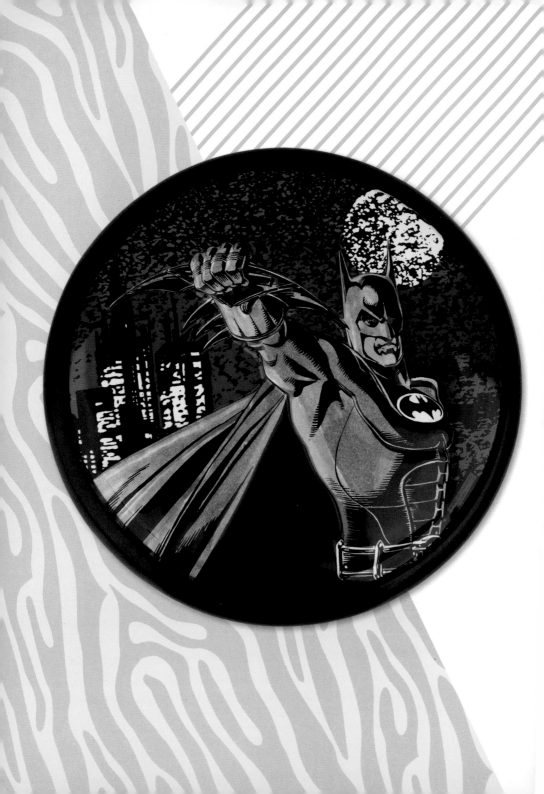

BATMAN

Created by comic book writer and artist Bob Kane, the Batman character first appeared in *Detective Comics* no. 27 in 1939. While people who don't read comics might not be familiar with Captain Marvel—the best-selling title of the industry's golden age—Batman is recognizable to the general population because Hollywood has thoroughly mined the superhero's story. Before Tim Burton's 1989 *Batman*, Adam West played the Caped Crusader on TV in the '60s, and there were animated series featuring Batman that aired in the '70s and '80s.

 The *Batman Returns* Frisbee, or "bat disc," probably wouldn't have been a terribly effective crime-fighting tool, but it would have provided you with hours of Batman-themed fun.

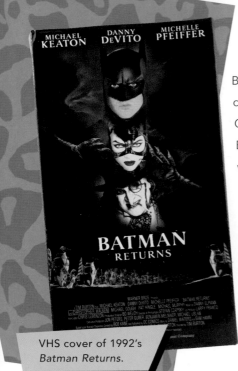

Burton's film, however, revamped the franchise. The story was still the same: Gotham City's billionaire playboy/philanthropist Bruce Wayne is a crime-fighting vigilante who wears a costume with a bat motif to intimidate crooks and hide his true identity. But Burton's film was darker, the score was foreboding, Batman had rubber abs, and we liked it. The film was a critical and box-office success—it won an Academy Award for art direction and jump-started our Batman obsession.

Batman was the decade's superhero. At the very least, he was Warner Bros. Entertainment's superhero, because he brought in a ton of cash for the company. When Burton's follow-up, *Batman Returns*, premiered in 1992, it had the highest-grossing opening weekend in history up until that point. In the film, the Dark Knight squared off against Michelle Pfeiffer's Catwoman and Danny DeVito's demented Penguin. The subject matter was bleak—the Penguin planned to kill all of the firstborn children in Gotham—and frightening—the Penguin bit into a guy's nose and then smiled as blood dripped down his chin—so naturally, all of the tie-in merchandise was marketed to kids, with your standard Happy Meal toys, action

The Happy Meal version of Catwoman and her . . . well, the package says it's a leopard.

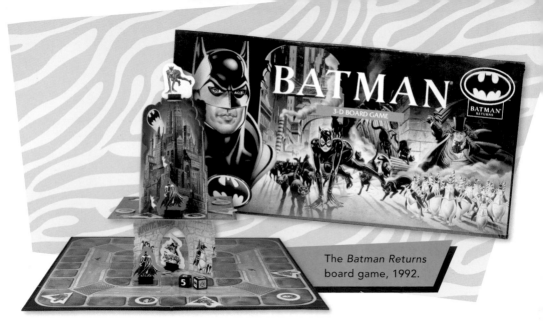

The *Batman Returns* board game, 1992.

figures, and Tiger Electronic handheld games. The *Batman Returns* 3-D board game was a regular board game with a small cardboard Gotham City standee in the center of it. So it was exactly as exciting as it sounded.

The same year, *Batman: The Animated Series* debuted. The simple fact that the show was an animated drama was enough to distinguish it from its contemporaries, but its distinct 1940s film noir–influenced visual style, sweeping score, and mature stories are all reasons why it is widely regarded as one of the greatest American cartoons. The series is also noteworthy for casting Mark Hamill as the voice of the Joker and for creating Harley Quinn, the Joker's henchwoman. Harley Quinn dressed like a harlequin clown and was so crazy in love with her "Mr. J" that he could demean her or even slap her, and she'd stand by him. The Joker Happy Meal

Jokermobile Happy Meal toy from 1993, based on *Batman: The Animated Series*.

toy may be the only one in McDonald's history to have been fashioned after a character who was guilty of domestic abuse.

BATMAN FOREVER

Two Batman films directed by Joel Schumacher would pop up by 1997—*Batman Forever* and *Batman & Robin*. In the latter, Schumacher decided to bathe everything in eye-assailing fluorescent light; thought it was OK to have Arnold Schwarzenegger's Mr. Freeze say, "Let's kick some *ice*"; made sure to zoom in on the dynamic duo's bouncing, rubber-clad butts; and gave the iconic bat costume erect nipples. In short, he did everything in his power to kill the franchise. For a while, it appeared that Schumacher's dastardly scheme had worked. But in 2005, director Christopher Nolan's successful reboot, *Batman Begins*, and its two sequels proved that the Caped Crusader will never die (as long as he remains nipple-free).

The Nightmare Before Christmas

When Jack Skellington, the Pumpkin King of Halloween Town, learns about Christmas, he decides to co-opt the holiday. Produced by Tim Burton, *The Nightmare Before Christmas* was a stop-motion musical featuring characters so cool and strange—pin-thin skeleton Jack, rag doll Sally—that you just wanted to decorate your room with them.

The Nightmare Before Christmas performed well at the box office when it was released in 1993, later becoming both a Christmas and Halloween TV staple, but its following has grown even larger over the years.

It's become a countercultural symbol—a favorite of goths—but is also beloved by animation fans and, of course, people who appreciate a sweet Halloween love story. In fact, more merchandise is produced now than when the movie was originally released—along with the expected T-shirts and lunch boxes, there are ceramic jar sets and Tiffany lamps.

During the holiday season, Jack Skellington-obsessed goth kids and clean-cut, middle-American families convene at the Disney theme parks, where characters from the movie take over the Haunted Mansion ride.

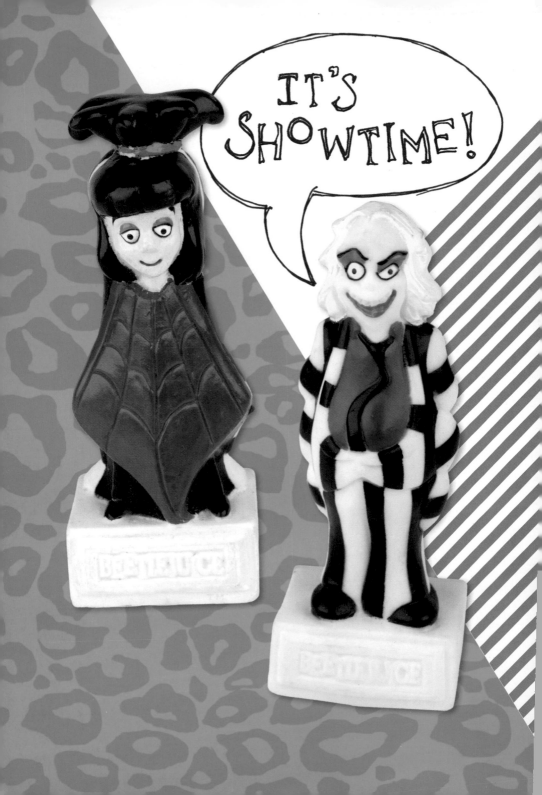

BEETLEJUICE

Batman was just one part of Tim Burton's agenda to make grim, dark subjects palatable for kids. We also had his *Beetlejuice* cartoon.

Raven-haired, sallow-skinned, and an admirer of all things spooky, Lydia Deetz, the even-tempered center of *Beetlejuice*, may have been a misfit at Miss Shannon's School for Girls, but you'd never catch her wallowing in misery while listening to the Cure. In fact, the hollow-eyed seventh grader was quite cheery. That's because Lydia was living the Goth-chick dream: her best friend was a dead guy. Beetlejuice, the "ghost with the most," and Lyds's ride-or-die homie, made life in sunny Peaceful Pines bearable with his ghoulish, kid-friendly brand of tomfoolery that included possessing Claire Brewster, the town's resident blond-bouffanted narcissist.

Lydia Deetz and Beetlejuice figures were among the six toys offered in Burger King kids' meals during a 1990 promotion.

IT'S SHOWTIME!

Beetlejuice initially aired Saturday mornings and was *very* loosely based on Tim Burton's 1988 movie of the same name. The biggest change was that poltergeist-for-hire Beetlejuice, who'd been the film's main antagonist and had

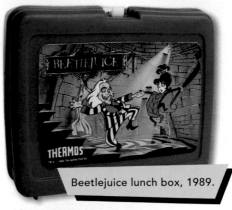

Beetlejuice lunch box, 1989.

attempted to force Lydia to marry him was, in the cartoon, Lydia's puckish buddy. Burton, no doubt, figured that America wasn't ready for a Saturday morning cartoon about a lecherous ghost trying to convince a middle-schooler to become his child bride. The show was playful, relying on gross-out humor and puns for laughs, and while there were ghouls and monsters, it wasn't nearly as dark as the movie.

The first episode began one year into Lydia and Beetlejuice's friendship, so it wasn't exactly clear how they met (or what, if anything, connected the events of the film with those of the TV series), but Lydia, who was generally seen as a weirdo by everyone in her school, summoned her prankster pal to the world of the living by saying, "Though I know I should be wary, still I venture someplace scary, ghostly haunting I turn loose, Beetlejuice, Beetlejuice, Beetlejuice." After reciting the incantation, her outfit magically transformed into the dopest red, spiderweb-print poncho (which I can't believe isn't being sold at Hot Topic). The series followed the duo's adventures in Peaceful Pines, Lydia's New England suburb, as well as in Beetlejuice's

'hood, the Neitherworld—a madcap, non-threatening version of the afterlife.

The Beetlejuice character was repurposed for the younger audience. In the movie, he was a lewd con artist. In the cartoon, he was a goofy, bug-eating, practical joker, taking his head off for yuks or posing as a handyman to mess with Lydia's parents, Charles and Delia. Whenever he was home in the Neitherworld, he could usually be found terrorizing his neighbors (French skeleton Jacques LaLean, tap-dancing spider Ginger, and the hairy monster who lived across the street, aptly named the Monster Across the Street), an eccentric but friendly bunch who were all clearly created to appeal to kids.

The most peculiar part of this retooling, though, was that the whole idea of death, which had been integral to the movie, was stripped from the show. The recently deceased couple played by Geena Davis and Alec Baldwin were cut from the cartoon entirely. Beetlejuice, who called himself a ghost, had grown up in the Neitherworld (there were flashbacks to his childhood), so he'd apparently never been alive and had therefore never died. Not having to deal with any of the tragic implications of death gave the writers more time to dream up all of those impressive episode-title puns ("Family Scarelooms," "Poultrygeist," "Substitute Creature").

Jacques LaLean, also part of the Burger King set.

DEADLY VU!

Beetlejuice originally aired 1989–1992, first on ABC and later on Fox on weekday afternoons. Despite its popularity and Emmy win, the show never had an official toy line. The Burger King *Beetlejuice* figurines, a Tiger handheld video game, and a couple of tie-in books were really all that fans had, and as I'm writing this, the show still hasn't been released on DVD. So why is *Beetlejuice* so memorable all these years later? Aside from the fact that it was basically on TV all the time—in 1991, it was airing on both Fox and ABC, so if you were a *Beetlejuice* addict, like I was, then you could watch the show six days a week—it was just totally different from any of its contemporaries. Stylistically, the animation was Burtonesque, filled with black and white stripes, sunken eyes, and curlicues.

Beetlejuice as snake charmer; the Sandworm appears on the flipside.

Computer-generated animation was also employed during some of the Neitherworld scenes, something that was uncommon at the time, and which created a kind of strange kitschiness. Personally, this show is so dear to me because when I was a kid I wanted to be Beetlejuice's friend and I was living vicariously though Lydia. She got to hang out with a dude whose head could turn into a giant Ferris wheel. None of my lame friends had heads like that.

The Real Ghostbusters

The cartoon, which aired 1986–1991, was supposed to exist within the same timeline as the 1984 movie about bustin' ghosts, but there were a few arbitrary changes that made it difficult to accept that. First, Slimer, who'd had an acrimonious relationship with the Ghostbusters in the movie, was the team's little pal in the cartoon. Second, Egon (Harold Ramis's character) had blond hair and Ray (Dan Aykroyd's character) had red hair. Maybe they didn't want to have a bunch of people with brown hair on the show, I don't know; nevertheless, it bothered me. The best thing about the cartoon: the Ecto Cooler. The delicious (and now discontinued) Hi-C drink was created as a tie-in to the series and featured a picture of Slimer on the box.

Bill and Ted's Excellent Adventures

The *Bill and Ted's Excellent Adventure* cartoon spin-off was broadcast in 1990–1991, and in the first season Bill, Ted, and Rufus were voiced by the actors who played them in the movie (Alex Winter, Keanu Reeves, and George Carlin), which almost never happens with these sorts of adaptations. Added bonus: Danny Cooksey, aka Budnick from *Salute Your Shorts*, was the voice of Ted's little brother, Deacon. The cartoon picked up where the most triumphant movie left off. In every episode, the guys traveled through time in a telephone booth, and Bill wore that weird '80s half shirt.

Back to the Future

This continuation of the Robert Zemeckis sci-fi trilogy was a mixture of live action and animation that saw Christopher Lloyd as Doc Brown doing science demonstrations with a pre-superstardom Bill Nye. Though Marty McFly did appear in the series, which took place in Hill Valley in 1991, the stories revolved around Doc Brown and his kids, Jules and Verne (who were introduced in the third movie). Dan "Homer Simpson" Castellaneta voiced the animated Doc Brown—his Christopher Lloyd impression was uncanny. The series ended after twenty-six episodes in 1992.

R.L. STINE

Goosebumps®

He's no fun in the sun!

T. JACOBUS
'95

THE ABOMINABLE SNOWMAN OF PASADENA

SCHOLASTIC

GOOSEBUMPS

When most people think "menstruation literature," Judy Blume's *Are You There God? It's Me, Margaret* immediately comes to mind. But for me, it's the Goosebumps series. You see, the evening before I got my first period, I was reading one of R. L. Stine's PG chillers. I can't remember the specific title of the book that I was holding during my final hours of being an "emotionally unencumbered, foot-loose and fancy free, go-swimming-whenever-I-damn-well-please" girl, but I'd like to think that it was *Monster Blood*.

★ *The Abominable Snowman of Pasadena* (1995) was the thirty-eighth book in R. L. Stine's original sixty-eight-book Goosebumps series. Tim Jacobus provided the cover artwork for all of the hair-raising tales.

One picture is worth a thousand screams.

SAY CHEESE AND DIE!

SCHOLASTIC

PARACHUTE PRESS, INC.

The fourth book in the series, from 1992.

READER BEWARE

Welcome to Dead House, the first novel in R. L. Stine's children's horror series, was published in 1992. When I was ten years old, it was the only book on my shelf with the word "dead" on the cover, and its presence in my room made me feel very sophisticated—like an adult, I was reading books about dead stuff. Many of the subsequent titles in the original Goosebumps series were equally provocative (*Say Cheese and Die!*, *The Headless Monster*, *The Scarecrow Walks at Midnight*, *Piano Lessons Can Be Murder*, just to name a few). Others, however, weren't quite up to snuff (*A Shocker on Shock Street*, *Legend of the Lost Legend*, *Say Cheese and Die—Again!*).

All of the protagonists were about eleven or twelve years old, only slightly older than Stine's target fourth-grade audience, which established an instant connection between the story and the reader. But beyond basic kid gripes like annoying little sisters and being forced to wear glasses (because you wouldn't be able to see without them!), nothing else bore any resemblance to preteen reality. Despite having titles like *My Hairiest Adventure*, these weren't coming-of-age novels. Instead, the middle schoolers at the center of each

eerie, supernatural mystery found themselves grappling with mischievous lawn gnomes, cuckoo clocks of doom, and ruthless worms—many of us, I'm sure, would have gladly swapped the actual horrors of adolescence for any of these things, the worms in particular.

But the kids were always smart, much smarter than their practically negligent parents who, I guess because they were old or had to pay taxes or something, couldn't see that moving to a swamp or a town called "Dark Falls" probably wasn't going to work out in the end. So yeah, Stine's characters appeared to exist in an inverted world where puberty wasn't real and monsters were, but their ability to triumph over the ghoulies and ghosties that pursued them, without the help of any adults, was kid-affirming. As fourth graders who weren't really looking for thematic complexity, we were down with that.

YOU'RE IN FOR A SCARE

Goosebumps books were supposed to chill your bones and creep you out, but I'd seen *A Nightmare on Elm Street* at an alarmingly young age (I think I was in the second grade), so they weren't at all scary to me. A haunted Halloween mask doesn't even compare to the idea of Freddy Krueger's metal claw shooting up from inside of my toilet bowl, grabbing me as I peed, and then pulling me into a terrifying toilet world (which was my biggest fear as a child and, let's just face it, right now as an adult). However, Goosebumps books were gripping. Every

Sticker pack, circa mid-'90s.

chapter ended with a cliff-hanger—a building *suddenly* disappearing, a ventriloquist dummy *suddenly* appearing, a character *suddenly* realizing that it

Goosebumps sticker.

was too late to escape—and while I don't know that that's actually a feature of good writing, the stories were enthralling to a person who had only just learned to read five years earlier.

THE GOOSEBUMPS EFFECT

Stine has said that his goal in writing is to show kids how entertaining reading can be—and with four million books selling every month at the height of Goosebumps' popularity in the '90s, he clearly accomplished that. But it wasn't just that Goosebumps got my generation reading (a lot of great children's authors were able to accomplish that): Goosebumps made us compulsive readers. We devoured Stine's stories with the voracity of *The Blob That Ate Everyone*'s titular blob, and until recently, Goosebumps was the best-selling children's book series of all time—as you may have guessed, Harry and his Hogwarts peeps Avada Kedavra-d that record. Goosebumps' success led to a TV show, a spin-off book series that followed the Choose Your Own Adventure format called Tales to Give You Goosebumps, and long before Harry Potter and Twilight merchandise was flying off store shelves, there were Goosebumps T-shirts, lunch boxes, video games, and toys. The extension of the Goosebumps brand is remarkable to me, though, because it wasn't driven by big-budget Hollywood movies, starring gorgeous actors with eighteen-pack abs. Goosebumps fanaticism was all about the books.

Other Genre Fiction Writers that We Loved

Christopher Pike

The transition from R. L. Stine's middle-grade reader Goosebumps to Christopher Pike's young adult thrillers may have seemed like a logical one, since the two authors were working in the same dark, mystery milieu but Pike books like *Fall into Darkness*, *Die Softly*, and *Remember Me* were the real deal. While Goosebumps characters bemoaned their freckled faces and complained about parents trying to get them to eat apples for lunch, Pike's characters were drinking beer, sexing it up, doing drugs (or alternatively, drugging their peers), contemplating abortion, and casually murdering one another. His books were also legitimately frightening, especially to a twelve-year-old. In *Road to Nowhere* (1993), an eighteen-year-old girl picks up two sketchy hitchhikers who turn out to be even creepier than you could possibly imagine. Science fiction, psychological horror, deranged dinosaur soap operas—Pike's fiction spanned the genres. Since 1985, he has written more than forty books, and to this day his work continues to captivate (and in some cases, traumatize) teen suspense junkies.

Bruce Coville

Want to know how cool Bruce Coville was in the '90s? R. L. Stine gave him a shout-out in a Goosebumps book, that's how cool. "The book I read is by Bruce Coville," begins Larry Boyd, the narrator of *My Hairiest Adventure*. "And I would recommend it to anyone who likes funny science fiction stories." Though Coville's work was popular with eight-to-twelve-year-olds (both fictional and real), it didn't have the same sort of mass appeal as Goosebumps. Coville's books were for those burgeoning sci-fi/fantasy buffs, kids who might go on to love Douglas Adams's *Hitchhiker's Guide to the Galaxy* or read some gargantuan Tolkien tome more than once. His My Teacher Is an Alien series (1989–1992) was a favorite of mine. It had that Goosebumps suspense, but it also dealt with the characters' personal issues (Peter, one of the protagonists of the series, is an outcast with a father who ignores him), something that Stine consciously avoided.

HOW **many** CELLS are in **YOUR** **BODY?**

BEAKMAN'S WORLD AND BILL NYE THE SCIENCE GUY

The world is a confusing place when you're a kid. You have no idea how much snow is in Antarctica; you don't know if alligators can walk backward or if birds sweat. Inevitably, you'll overhear your friends discussing biodiversity and light optics while playing four square, and even though you've managed to pick up a bit of information on both of these subjects, it definitely isn't enough to sustain a conversation for much more than a minute or two. My generation didn't have to stress out about all of this, though, because we had Beakman and Bill Nye—two charming TV hosts who demystified the mystifying, cracked the seemingly uncrackable, and always made sure that we didn't try to use a pair of scissors without adult supervision.

The four player pieces from the *Beakmania* trivia-based board game and a *Bill Nye the Science Guy* interactive trading card.

Picking up where '80s staple *Mr. Wizard's World* left off, *Beakman's World* and *Bill Nye the Science Guy*, premiering in 1992 and 1993, respectively, were educational TV programs that taught us about things like thermodynamics and chemical reactions in ways that were easy to comprehend, stimulating, and modern—the editing was frenetic and there were more arbitrary sound effects than a morning radio show. Beakman (portrayed by actor Paul Zaloom) and Bill Nye (portrayed by none other than Bill Nye) did fascinating demonstrations and mini-experiments with household objects, proving that we were all just a rubber band, a paper towel tube, and a plunger away from being bona fide scientists.

BEAKMAN VS. BILL NYE

Even without the lab coat, the bow tie, and the prim, professorial haircut, Bill Nye would have still given off a "science guy" vibe. There was a kind of avian quality about him—from his beakish nose to his spindly bird legs—that, for some reason, just screamed, "I've devoted my life to Bunsen burners and test tubes." I don't mean to imply that he was unattractive or incapable of making a preteen girl swoon, but he looked smart. Not nerdy, but intelligent—authoritative, even—and if I'd met him on the street, having never seen a single episode of *Bill Nye the Science Guy*, and he'd told me that inertia is a property of matter, I would've been inclined to believe him.

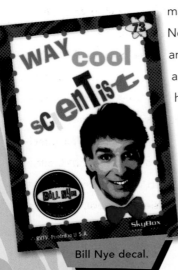

Bill Nye decal.

Beakman, on the other hand, was inscrutable. He was a wild card. Yes, he wore a lab coat, but it was neon green, and that isn't a color that most people trust implicitly. Beakman's hair stood on end in a way that would seem

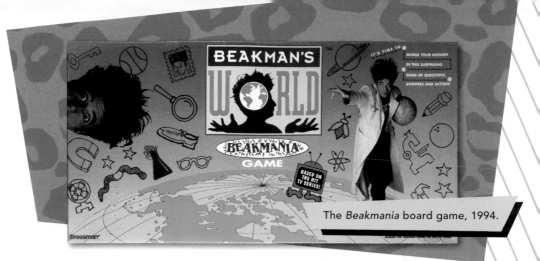

The *Beakmania* board game, 1994.

to suggest that he ritualistically electrocuted himself or that he had a gem embedded in his belly button. I wouldn't call Beakman a mad scientist—I don't know that many mad scientists are overly concerned with using potatoes and two-liter bottles to demonstrate how vortexes work—but he was certainly a zany scientist (although, I suppose "zany scientist" must fall somewhere on the "mad scientist" spectrum).

CONSIDER THE FOLLOWING

Albert Einstein, Thomas Edison, Marie Curie, Isaac Newton—yeah, they did some things and that's great and all, but would any of them have been able to get an eleven-year-old *Street Fighter II* obsessive or a nine-year-old who'd just polished off an entire six-pack of Squeezits to listen to them for more than thirty seconds? It's unlikely. We honor the achievements of Charles Darwin and Jonas Salk, but it has to be just as difficult to get a hyper kid to sit down for twenty-six minutes, listen to an explanation of how the human circulatory system works, and then retain that information, as it is to come up with the theory of evolution or cure polio. I'm not saying that we shouldn't appreciate the work of history's greatest thinkers, because we obviously should, but *Beakman's World* and *Bill Nye the Science Guy* showed kids why those people should be appreciated—they allowed us to see that science is cool, and that's important work, too.

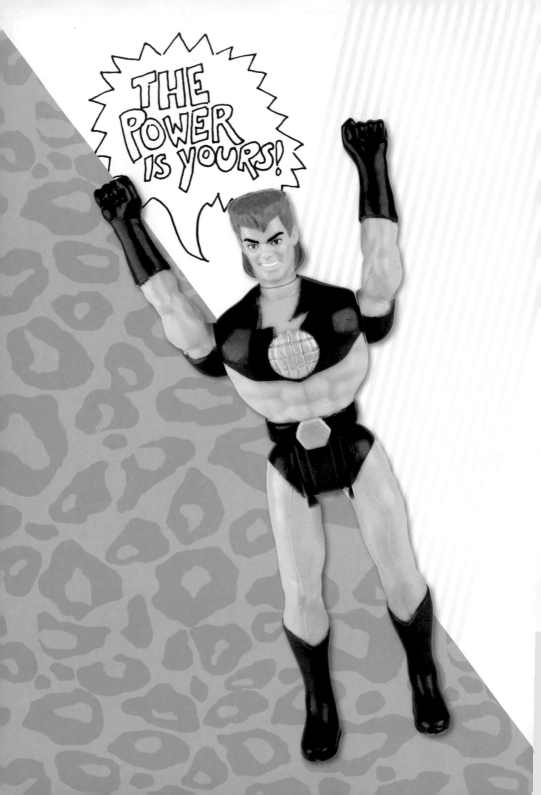

CAPTAIN PLANET

Captain Planet's raison d'être: take pollution down to zero. And in episode after episode of *Captain Planet and the Planeteers*, he'd combat some environmental threat. If, say, mutant nuclear terrorist Duke Nukem (no relation to the enduring video game character) had set off a nuclear power plant meltdown, Captain Planet would rip the entire power plant from its foundation and throw it into the sun—teaching us that nuclear power is dangerous and that space is a suitable depository for just about anything that we don't want to deal with here on Earth.

 The Captain Planet action figure was introduced in 1991. Apart from the toy's demonic red eyes, it was identical to the cartoon superhero.

Captain Planet sparkled, he had red boots, he inexplicably wore a belt to hold up his underwear, he was the captain of a whole planet. These are all desirable qualities, the sorts of things that, now, I look for in a man—but when I was seven, Captain Planet wasn't someone I idolized. Despite his altruism, I don't think anyone really revered the character in the same way that we may have revered Batman or the X-Men or Blossom (but if you did revere him, I'm sure that as an adult, you've gone on to do very impressive things). So why were we watching this show every weekday morning?

The appeal of *Captain Planet and the Planeteers* was the theme song, which was this inspired piece of synth pop. It was layered with random keyboard flourishes and a bass line that was funky—not too funky, but sort of wholesomely funky. There was also sincerity behind the vocals. It was as if the woman belting out the tune genuinely believed that Captain Planet was our powers magnified. Finally, on the tail end of the theme, there was this quasi-rap ("We're the Planeteers / you can be one too / 'cause saving our planet is the thing to do . . ."), and, like any indoctrinating chant, it was fun to sing-talk along with.

THE STORY

Cocreated by media mogul/all-around rich dude Ted Turner in 1990, *Captain Planet and the Planeteers* was an animated TV series with a noble agenda, one that stretched beyond simply peddling Burger King Kids Meal toys (though, thank God, there were Burger King Kids Meal toys): the show promoted environmental conservation. But

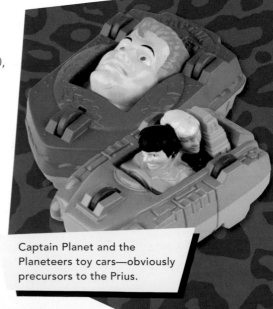

Captain Planet and the Planeteers toy cars—obviously precursors to the Prius.

because taking care of the earth and social responsibility or whatevs are totally boring concepts, Captain Planet, a blue superhero with a green mullet (a hairdo that I imagine must have been very aerodynamic) was used to make the subject more palatable for kids.

The Eco-Villain Duke Nukem.

In the first episode, Gaia, the spirit of Earth, awakens from a century-long siesta. After seeing all of the damage that humans have done to the environment during her catnap, she decides to shirk her responsibility and call on five teenagers from "five corners of the globe" to save the planet. She then gives each member of this team, dubbed the Planeteers, a magical ring that will allow them to control one so-called power of nature. These powers are earth, fire, wind, water, and heart—the last one, I think, thrown in there for shits and giggles.

Instead of doing their homework or having any other normal teen experiences, the Planeteers used their rings to stand up to Eco-Villains like Verminous "I'm-definitely-naming-my-first-born-child-after-this-guy" Skumm, a sinister rat-man hybrid who got his jollies by doing things like contaminating water supplies. When faced with a situation that they couldn't handle, the Planeteers would combine their powers and Captain Planet would materialize, foiling the bad guy's ecologically reckless scheme.

After he'd taken care of business, Captain Planet would say, "The power is yours," meaning that the Planeteers, and the viewers by extension, had the ability to make a positive change in the world and to protect the planet from "bad guys who like to loot and plunder." But I don't know how valid that message was because I've never been able to stop a firestorm by flying up into a cloud and triggering precipitation. So I'd have to say that the power was Captain Planet's and Captain Planet's alone.

by our powers combined...

MEET THE PLANETEERS

If *Captain Planet and the Planeteers* were the late-'90s girl group Destiny's Child, then Captain Planet would have been Beyoncé and the Planeteers would have been the non-Beyoncé girls standing behind Beyoncé—that is to say, they were important, but not really that important.

Kwame
Region: Africa
Power: Earth
In every episode, right before the team summoned Captain Planet, Kwame, the levelheaded, unofficial leader, would say, "Let our powers combine." Oddly, no one ever called him out on his unnecessarily formal syntax.

Wheeler

Region: North America
Power: Fire

Hailing from Brooklyn, loud-mouthed Wheeler was, at his core, an ass, and from time to time he would call Linka (with whom he had some sexual tension) "toots." While cleaning oil-covered sea animals, Wheeler says, "We didn't make the mess. So, why do we have to clean it up? We're not getting paid any money." He was the kind of character that just made you super proud to be American.

Linka

Region: Soviet Union (later changed to Eastern Europe after the Soviet Union collapsed)
Power: Wind

Blond, feisty, and wearing cargo shorts that appeared to be just a little bit shorter than everyone else's, Linka was the sexy Planeteer. The lighthearted jabs that she exchanged with Wheeler (once calling him "my sweet imperialist dog") can be seen as the last-remaining vestiges of the Cold War.

Gi

Region: Asia
Power: Water

Animal lover Gi would overemphasize both syllables in "water," so whenever she said the word, it sounded strangely dramatic. She was usually at the helm of the Planeteers Geo-Cruiser (an eco-friendly plane) despite being a kid and never having taken any Geo-Cruiser flying lessons.

Ma-Ti

Region: South America
Power: Heart

Ma-Ti was short, sensitive, and sanctimonious. His ring gave him the ability to read people's minds and feel their feelings, which, as far as Planeteer powers go, seemed lame and a bit creepy.

THE POWER IS YOURS

There was a time in America, several decades ago, when people would put their garbage wherever the hell they wanted without giving it a second thought. They'd toss it up above their heads and watch as it floated down to Earth like confetti, they'd throw it like a football into the trees to impress their girlfriends, they'd pitch it into a lake and count how many times it skipped across the water, and sometimes they simply dropped it on the ground. I have never and probably will never be able to litter. I can't just open up a candy bar and drop the wrapper wherever. If there's no trash can in sight, I'll keep that wrapper in my pocket until I come across one. This isn't because I'm worried about

Of course there was a fanny pack.

fines, and I'm far too lazy to be an environmentalist, but littering makes me feel extraordinarily guilty. In my mind, littering ranks right up there with other vile offenses like theft, assault, and gerrymandering. I blame Captain Planet for this.

Captain Pollution

From *Super Mario*'s Wario to *Where's Waldo*'s Odlaw, everyone has an evil doppelganger. They're all nuisances, but they're necessary and provide the world with a sense of balance. Captain Planet's double, Captain Pollution, had the same physique and penchant for wearing red undies in place of pants as the environmentalist superhero, but he was yellow, covered in brown grime, spoke like a California surfer dude, had a nefarious red mullet, bathed in a vat of toxic chemicals, and once called the Planeteers "nature nerds" (which they totally were). He's introduced in a first-season episode of *Captain Planet and the Planeteers* called "Mission to Save Earth," wherein the tech-savvy female Eco-Villain Dr. Blight invents a machine that analyzes any object and makes an evil duplicate (it's hard to believe actual scientists aren't investing time into developing something so useful). Dr. Blight and four of the show's most notorious baddies—Duke Nukem, Looten Plunder, Sly Sludge, and Verminous Skumm—steal the Planeteers' magic rings and put them in the machine, creating five rings of destruction that give them the powers of super-radiation, deforestation, smog, toxins, and hate. When combined, their rings form Captain Pollution—who, as it turns out, is the least menacing arch-nemesis of all time. To incapacitate the guy, all one needed to do was squirt him with water.

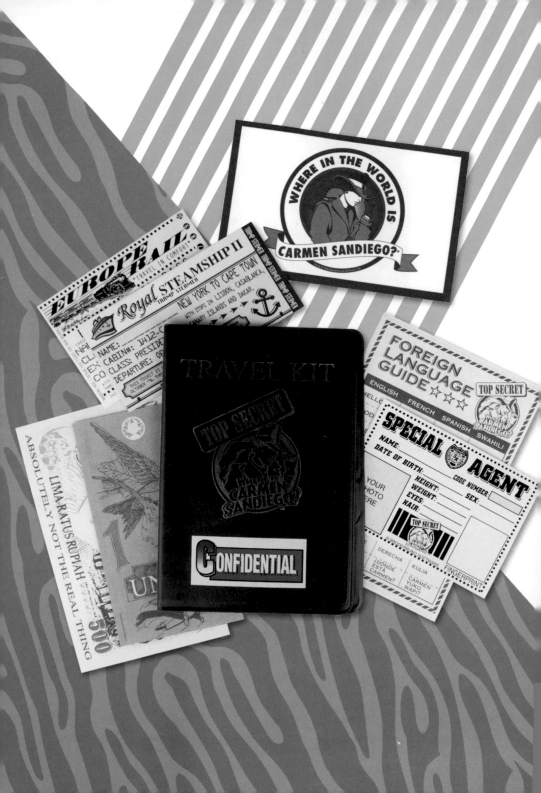

WHERE IN THE WORLD IS CARMEN SANDIEGO?

Most thieves try to be as inconspicuous as possible; they slink around in the shadows, wear masks, and only steal candelabras, fine china, and other reasonably sized things that can fit easily into one of those large burlap burglar sacks. But "sticky-fingered filcher" Carmen Sandiego was brazen about her crimes. Her face may have been partially obscured by her wide-brimmed hat, but she wore a flashy red trench coat, never once opting for a low-key ensemble that might afford her a bit of anonymity and certainly never deigning to stand in the middle of a huge crowd scene amongst people dressed almost identically to her in an effort to avoid detection like the equally elusive Waldo. Carmen's boldness extended to the items that she and her V.I.L.E. henchmen stole, which often weren't items at all, but landmarks

A card from the *Where in the World Is Carmen Sandiego?* board game (top) and a Wendy's kids' meal Carmen Sandiego travel kit with all of the documentation that a child with a vivid imagination would need to track down the notorious thief.

and monuments like Ellis Island and the Eiffel Tower. And yet, it was impossible to find her. How could it be so difficult to apprehend a woman dressed entirely in red, toting the Eiffel Tower? For Christ's sake, no one even "Arkan-*SAW* her steal the Mekong from the jungle!"

THE SEARCH IS ON

The first *Where in the World Is Carmen Sandiego?* computer game was produced by Brøderbund Software in 1985, and by 1994 the program was being incorporated into elementary school curricula across the United States. It was edutainment designed to encourage an interest in geography and world history by tricking kids into thinking that they were just having fun when they were actually learning. A spoonful of international crime helped those facts about Bamako (the capital city of Mali) go down.

Players began the game as a "rookie" working for the ACME Detective Agency and were tasked with tracking down one of Carmen Sandiego's underlings, who would have stolen something odd but historically significant, like the Staten Island Ferry or the throne of Timbuktu. You'd start your journey in the country where the loot was stolen and by clicking on a crudely rendered (by contemporary standards) image of a palace, a library, or some other pub- lic building, you were able to ask townspeople questions about where the crook was headed. They would give you clues like, "The suspect wanted to see what made Big Ben tick," which seemed incredibly cryptic when you were ten years old. When you finally figured out that Big Ben was in London by consulting the handy "almanac and book of facts" that was packaged with the game or by guessing

(if, like my school, yours didn't have no fancy game book), you'd click London on the world map and then continue the search in this new location. Once you'd apprehended the criminal, you'd be promoted, and during the final round of the game you'd be tailing Carmen Sandiego (but I don't know a single person who made it that far).

Location cards from the board game.

DO IT, ROCKAPELLA!

The *Where in the World Is Carmen Sandiego?* game show followed the same general structure of the computer game, with the middle-school–age contestants attempting to catch one of Carmen's henchmen by tracking clues and answering geography questions. It aired on PBS in 1991–1995 and I, like so many others, desperately wanted to be on it. The grand-prize winner was awarded a trip to anywhere in North America they wanted to go, but I couldn't have cared less about that. The contestants got to wear these garish red and yellow jackets that I thought were too cool, and I would have given anything to try one on. The game show's theme song was performed by an a cappella group called Rockapella. When I was in high school, I saw the group perform at the local Harvest Festival and it was, without question, one of the top-five best moments of my teen years (which I think tells you a lot about how hard I partied back then).

NO, BUT SERIOUSLY, WHERE IS SHE?

The Carmen Sandiego franchise expanded to include an animated series, *Where on Earth Is Carmen Sandiego?*, as well as several sequels to the

original computer game like *Where in Time Is Carmen Sandiego?* and *Where in America's Past Is Carmen Sandiego?* but strangely no *Where in San Diego Is Carmen Sandiego?* I owned the board game and even though I'm sure that it had rules and objectives and whatnot, whenever I played it with my neighbor, we just asked each other the geography questions on the game cards (and never got the answers correct). Ultimately, *Where in the World Is Carmen Sandiego?* was important to kids in the '90s because it was through the original game that a lot of us were introduced to computers.

Carmen Sandiego was a globe-trotting woman at the helm of an international crime syndicate and one of the decade's most intriguing characters. I never figured out where in the world she was, so I can only assume that Carmen's still out there putting the "miss" in misdemeanor.

The Oregon Trail

The Oregon Trail had been around since the late '70s, but the 1992 edition of the game was what we played in the computer literacy class at my elementary school. Based on the historical Oregon Trail that nineteenth-century travelers used when making their way to the west, the game was designed to teach kids about pioneer life in 1848. The objective was to trek from Missouri to Oregon in a covered wagon with a group of settlers. Along the way, you would have to contend with some of the harsh realities of that difficult journey like dangerous river crossings, snow, and disease. For food, you'd hunt buffalo, which you shot by clicking animated images of the majestic creatures. My computer literacy teacher put a limit on the number of buffalo that we were allowed to kill because kids were shooting them for fun and not sustenance.

Age 10 to Adult

THE OREGON TRAIL™

IBM/Tandy
PC/XT/AT, PS/1®, PS/2®
and 100% compatibles;
512K minimum memory;
CGA, EGA, MCGA,VGA,
DOS 2.1 or higher.
Includes 3.5" and 5.25" disks

mecc
For the love of learning.

If you were playing at school, it was customary to name the members of your traveling party after friends sitting at nearby computers. When the characters perished, as they inevitably would, you'd shout, "Hey, Susie! You just died of dysentery" or "Tommy, you drowned while I was trying to ford the river" and the classroom would erupt in laughter. Like true, hardened pioneers, we took death in stride.

TIGER ELECTRONIC HANDHELD GAMES

I don't know how true this is, but I once heard that rapper Master P— at the height of his fame—would throw away his sneakers after wearing them once. At ten years old, I wasn't making anyone say, "uhh, nah na nah na" (and still have yet to do so), but you would've thought that I was if you'd observed the wanton disregard that I had for my Tiger Electronics handheld games. The problem was that Tiger handhelds were dedicated consoles, meaning that you could only use them to play one built-in video game—there was no switching cartridges. So after beating the game (or in my case, never beating the game), you'd be done with it, at which point, the standard procedure was to misplace it.

 WCW Grudge Match, Ninja Fighter, and *Mighty Ducks* were among the hundreds of exciting Tiger Electronics handheld game titles.

You'd have your *Aladdin* game one day, and two weeks later, it'd be a distant memory. I think most of us went through Tiger handhelds faster than Danny Tanner and his full house went through toilet paper.

FUN ON THE RUN

Tiger Electronics was producing LCD handheld games in the '80s, but they started churning them out like crazy in the early to mid-'90s. *The Little Mermaid*, *Batman*, *Jurassic Park*, Shaquille O'Neal, Pop-Tarts—it seemed that anything that kids might be remotely interested in was turned into a handheld (OK, so there was no Pop-Tarts game, but surely the idea was brought up during a board meeting at some point). This was bare-bones electronic gaming, just a step up from using a calculator, and with Sega and Nintendo releasing their superior handheld consoles around this time, Tiger's games looked totally remedial—like something that *Homo habilis* might have gotten a kick out of, but definitely not a person who knew that Game Gear existed. The design was simple. The LCD screen, controls, and speaker were a single portable unit. During gameplay, the graphics flashed across a single, static background image, simulating movement.

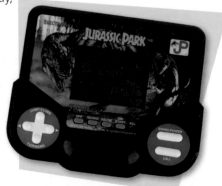

There were usually four or five gameplay stages that, like all video games, increased in difficulty as you progressed. As you used the directional control pad to move from the left to the right of the screen (that's essentially all that you could

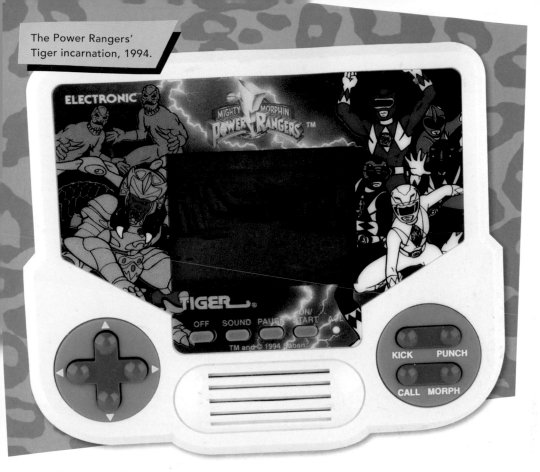

The Power Rangers' Tiger incarnation, 1994.

do in most of these games), the device emitted a series of uninspired bleeps and bloops that I think were supposed to enhance the experience but really just sounded like you were setting your digital watch.

Despite this primitiveness, they were hypnotic. I can't even begin to tell you how many times I slipped into a Tiger handheld trance. You could be playing the *Darkwing Duck* handheld while *Darkwing Duck* was on TV, and the game would be more compelling. Plus, they were relatively inexpensive, certainly much cheaper than a Game Boy. So if a confused uncle was searching for a gift for you, all he had to do was remember that you liked the Power Rangers, shell out like twenty bucks for the *Power Rangers* handheld, and he'd gotten you something that you'd really like and appreciate for a couple of

weeks. When you got bored with the game, no one was upset because it had barely cost any money.

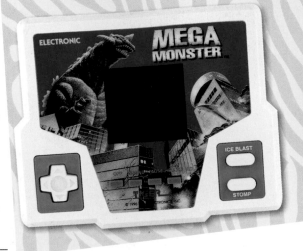

The temporary nature of these games makes it hard to recall specifics about any one title. What I remember most about Tiger handhelds, though, is the stiff, plastic packaging that they came in— even when I cut through the plastic, I had difficulty liberating the game, and most times I'd end up scratching my hands on the sharp edges. But a lot of the things that I enjoyed as a kid were almost impossible to open. Tiger handhelds rank right up there with Capri Suns, school lunch chocolate milk cartons, and bananas.

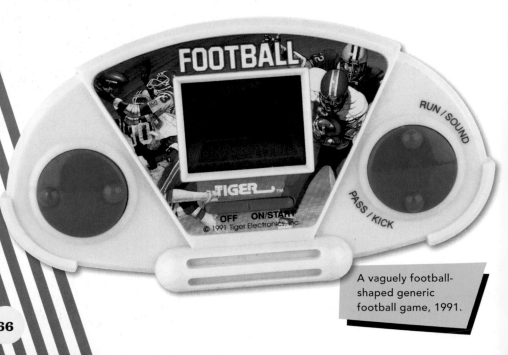

A vaguely football-shaped generic football game, 1991.

Lights Out

Released in 1995,
Tiger's *Lights Out* was
a handheld electronic
puzzle game with
a five-by-five grid
of purple buttons.
Some buttons were
lit, some unlit. When
you pressed one of
the glowing buttons,
the light shut off but
the adjacent buttons
would light up. The
object of the game
was to turn off all
of the lights in the
fewest number of
moves. *Lights Out*
was kind of like
a '90s version of
the Rubik's Cube
in that simply
holding it made
you appear smart
even if you had
no idea how to
solve it.

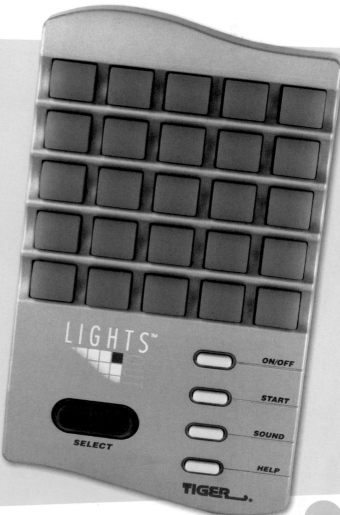

DISNEY AFTERNOON

The Disney Afternoon was a two-hour block of syndicated cartoons that began airing in 1990. A few of the cartoons in the lineup were original properties, not connected to the Disney canon, while others were new takes on familiar Disney characters. *TaleSpin*, for example, had Baloo the bear from 1967's *The Jungle Book* assuming the role of a bush pilot. With most of the shows, though, the unifying principle was that anthropomorphized cartoon animals should wear shirts but not pants.

Clockwise from top left: *TaleSpin*'s Baloo, *DuckTales*' Louie, Darkwing Duck, and Cubbi Gummi of *Disney's Adventures of Gummi Bears*. These PVC Disney Afternoon figures were Kellogg's cereal prizes.

HERE'S WHERE THE FUN BEGINS

Every day after school you'd sit in front of your TV, maybe with some Shark Bites fruit snacks and a juice box, and watch Disney Afternoon shows like superhero parody *Darkwing Duck* and *Chip 'n Dale: Rescue Rangers*, an adventure series about two chipmunk detectives. Many of the decade's most memorable cartoons were included in the lineup at one point or another. In its premiere year, the block included *Disney's Adventures of Gummi Bears*. The cartoon's title was deceptively delicious and didn't have any correlation to the candy of the same name. Instead, it was about medieval bears who'd drink something called Gummiberry Juice. The juice, per the show's theme song, gave them the ability to hop not only "here" and "there" but also "everywhere."

Goof Troop was introduced in 1994 and provided Goofy, Mickey Mouse's canine cohort, with a backstory. In the series, Goofy was the single father of a preteen boy named Max. This was the most disturbing of the Disney Afternoon cartoons, because its premise implied that at some point Goofy had had sex and that maybe he wanted to have sex again. Aside from the occasional discomfiting subtext, the shows were overwhelmingly innocent. Calling the block "the Disney Afternoon" was a way of telling parents that these two hours reflected Disney's wholesome values.

Almost every show that aired during the block's seven-year run was made into a video game, *Gummi Bears* being a glaring exception. I can't see any self-respecting gamer or even a self-loathing gamer ever wanting to play something called "Gummi Bears" unless that game was about biting the heads off

The mostly wholesome Goofy.

bear-shaped candies and it wasn't a game but real life and you were just eating tasty Gummi Bear candies.

It wasn't long before characters from these cartoons made their way into the Disneyland Theme Park. A now-defunct attraction called Disney Afternoon Avenue gave fans the chance to give Baloo or Chip and Dale a hug or ask them questions that they wouldn't be able to answer because the people in those costumes aren't allowed to talk.

LESSONS LEARNED FROM THE DISNEY AFTERNOON

Scrooge McDuck lovin' his money.

DuckTales, maybe the most renowned of the bunch, taught us that there's only one thing better than owning a vault full of cold, hard cash, and that's swimming in it. The show revolved around identical triplets Huey, Duey, and Louie, and their great-uncle, Scrooge McDuck (Donald's uncle), a miser with a "Money Bin" the size of the Sears Tower. Crooks were always after his riches, though—trying to con him or just break into his vault. So, as fun as Scrooge made diving into a sea of gold doubloons look, *DuckTales'* overall message was that with mo' money comes mo' problems (something that Biggie, Mase, and Diddy *née* Puff Daddy would reiterate later in the decade). Regardless, I'd still like mo' money, please.

Disney Adventures

An interview with Jonathan Brandis, a backstage look at the Mighty Morphin Power Rangers Live Tour, profiles on eight-year-old spelunkers: *Disney Adventures* magazine was a hodgepodge of just about everything that kids might be interested in. Mini-comics were interspersed throughout, often based on shows like *TaleSpin* and *Darkwing Duck*. The magazine featured puzzles and games as well as educational articles—in one issue Bill Nye explained the science of tsunamis. The first issue was published in October 1990, and in its seventeen years in print stars like Michael Jackson, Arnold Schwarzenegger, and Bronson Pinchot graced the cover.

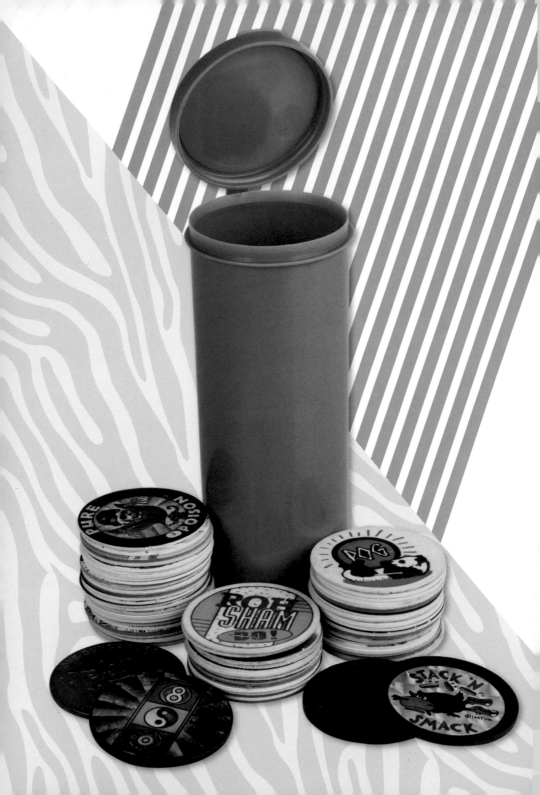

POGS

There was an episode of *The Simpsons* where Bart sold his soul to Milhouse, and then Milhouse traded the soul away for ALF pogs. In 1994, most of us would've gladly exchanged one measly soul to get a handful of those wondrous scraps of cardboard.

Pogs were a kind of currency back then—a social currency. If you had a lot of them, then you were awesome and had some cachet in your local pog community. If you didn't have a lot of them, then you had financially responsible parents. I'm guessing they passed down their wisdom and that you aren't in debt right now. (Good job, your parents!) It's not that pogs were expensive, but having to pay for them at all, when you could have easily made your own, was crazy.

 Anyone who was anyone in the '90s had a pog storage tube, stacks upon stacks of pogs, and heavy-duty slammers.

POGS?

In the simplest terms, a pog is a small cardboard disc. In the most complex terms, it's still just a small cardboard disc. They were a little more than an inch in diameter and on one side there was an image. This image might be an illustration of your favorite cartoon char-acter, a photograph of Michael Jordan, a holographic design, but mostly, for reasons unknown, it would've been a picture of an 8-ball or a yin-yang symbol. The reverse side of the pog was usually blank.

You could've stared at your pogs, obsessively counting them every day, the way I did, or you could've used them as they were intended: to play pogs. In order to play the game, you needed something called a slammer. Like a pog, a slammer was a disc, but it was made of plastic or metal and was thicker—the badass slammers were more than an inch thick. When you were ready to begin, you and a friend would stack up your pogs facedown, each of you contributing an equal number to the stack, and then you'd take turns throwing, or rather, "slamming," your slammers down onto the top of the pile. If you were hard-core, every pog that you flipped over would become your property, but my friends and I were polite children and would return the pogs we'd won at the end of the game.

By 1995, I'd lost interest and had abandoned the dream of getting rich via pogs—I'd been a pog speculator and had planned on one day selling my collection for millions of dollars. That was around the time that the fad died out. The most peculiar part of the phenomenon wasn't that people were paying actual money for bits of cardboard or even that some of us genuinely cherished that cardboard; it was that we all blindly accepted the word "pog."

No one even wondered about the etymology or how the word could even begin to describe these things that we were playing with. For the record, the word is actually an acronym. The game, which had been popular with kids in Hawaii since the 1920s, was originally played with milk bottle caps and then later the caps from a passion fruit, orange, guava juice blend.

ALL POGGED OUT

There was a purity in pogs. The game wasn't electronic, but we all loved it. It reminds me of kids playing jacks in the days before video games. However, it was gambling, and that's disconcerting. Somewhere, there must have been an eleven-year-old with a debilitating pog addiction whose life had spun dismally out of control by the end of the decade.

Magic: The Gathering

How should I put this? *Magic: The Gathering* was a fantasy-based trading card game played by people who were . . . not into sports. It was released in 1993, and I remember a lot of boys with fanny packs playing it (no judgment). There were different card types, like "land" or "creature," and when you were ready to play, you'd construct a deck by strategically picking out the cards from your collection that you thought would give you the biggest advantage against your opponent—these cards were like your weapons. Everyone playing began the game at "20 life" and you won by bringing your opponent down to "0 life." I want to say that it was like *Dungeons & Dragons*, but I know that doing so would offend both people who play *Magic* and people who play *Dungeons & Dragons* (though I'm sure there's some overlap in those two groups). *Magic* is still popular and championship games have been broadcast on ESPN to give jocks some insight into how the other half lives.

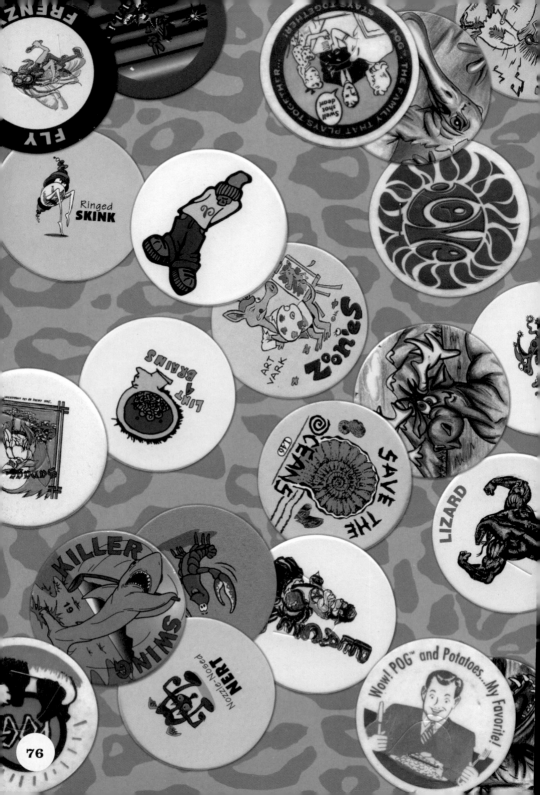

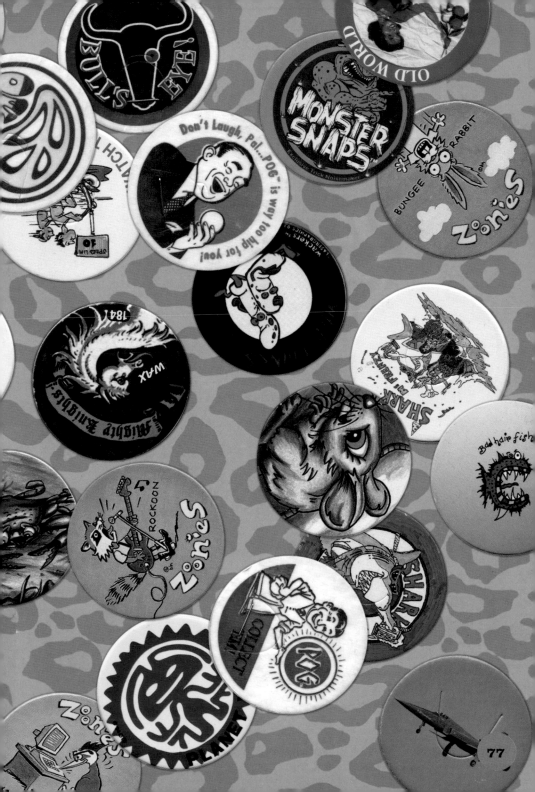

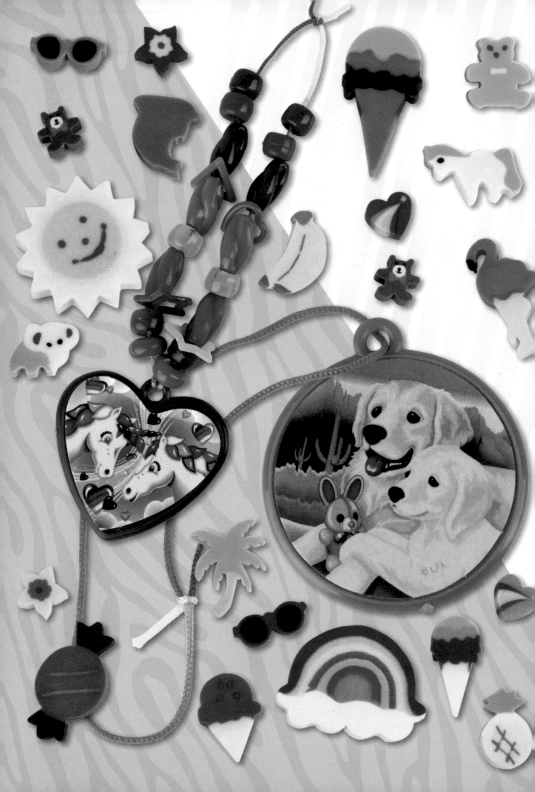

LISA FRANK

n Lisa Frank's fantastic world, nothing could ever be too bright; no animal pairing was too far-fetched (a penguin and a brown bear could walk side by side without reproach); magenta, yellow, and fluorescent green were complementary colors; rainbows weren't refracted and reflected light, but surfaces to be danced upon by a ballerina bunny perpetually in mid-pirouette; unicorns pranced across clouds; and adorable golden retriever puppies ate sundaes covered in chocolate syrup without anyone having to consider the havoc that it might wreak on their canine digestive systems. In short, Lisa Frank's world was immeasurably superior to ours. While it's generally believed that her flamboyant designs could have only been created during a psychedelic

A colorful assortment of yummy Lisa Frank erasers and necklaces showcasing popular characters from the designer's product line: golden retrievers Casey and Caymus and rainbow unicorn Markie.

drug–induced hallucination, if you study the images closely, I think you'll find that, yes, that lady was tripping balls.

YOU GOTTA HAVE IT!

Lisa Frank had a dream that she would one day live in a nation where little girls would not be judged by the content of their character but by how many dolphin stickers they had. And even though her company was founded in 1979, her dream was realized in the '90s. If you didn't have any of the designer's products, you weren't cool. You wouldn't be shunned by your peers, at least not where I was from—no one would look at your monochromatic school supplies and say, "What a loser—I can't believe that your folder doesn't have a picture of two purple penguins locked in an amorous embrace atop an iceberg." But the lack of coolness was definitely something that you felt. When all of the girls around you have rainbow leopard print binders and your binder is just blue, it's hard not to internalize your otherness.

Commercials and magazine ads encouraged us to collect everything in the Lisa Frank line, which ranged from backpacks and notebooks to sweatshirts and sleeping bags to "glitter wands." My personal favorite: the erasers. Some were shaped like fruit and the tiny pink and purple ones looked like candy; somehow, I was able to restrain myself from putting them in my mouth. Lisa Frank zealots could join Club Lisa Frank, where your lifetime membership was contingent upon doing things like ordering items from the company's catalog every year and

referring others to the club. Lisa Frank was offering more than cute stationery; she was offering a way of life.

TOTALLY LISA FRANK!

Lisa Frank products were so incredibly gaudy but also so incredibly appealing. The plastic jewelry, diaries, and the rest of it were all girlier than the girliest thing a girly girl could ever hope to own. The intense color palette was eye assaulting, but that was part of what made her product line so fun. The designs were feminine but not dainty. There was a boldness about them that was attractive to a brassy, self-possessed '90s girl.

Hollywood Bear in shades.

Sanrio

Sanrio offered an alternative stationery and sticker-based lifestyle for young girls. The Japanese company may be best known for its Hello Kitty character, but the cartoon cat had a slew of ultracute buddies who debuted in the late '80s and '90s and cropped up on the notebooks of girls during the era. There was Pochacco, a dog who, like Hello Kitty, was mouthless but somehow managed not to die from starvation; Badtz-Maru, the surly-looking penguin; and Keroppi the frog, to name a few. The Sanrio store doubled as a place of worship for girls who were devoted to the company's wares.

GIRL TRENDS

The '90s were a time of transition for fashion. We were going from the flamboyant, totally radical style of the '80s to the more muted and sensible designs of today. The muddling of those two disparate ideas led to a lot of unfortunate fashion trends, especially for young girls.

Blossom Russo, the precocious teenage title character on the TV series *Blossom*, who popularized the "Blossom hat."

SPANDEX! ALL SPANDEX!

When I was in the second grade, I was all about biker shorts. Seriously, my defining characteristic was biker shorts. I'm sure that I must have had tons of these cotton, spandex eyesores, but my favorite were the ones with the lace trim—they were so classy.

I call them "eyesores," but with a little creativity, they didn't have to be. Melissa Joan Hart may not have been the originator of the style, but she definitely pulled it off with the most panache. On *Clarissa Explains It All*, she'd often rock printed spandex shorts—something that I was far too cowardly to attempt—but pair them with an oversized button-down shirt and that requisite Clarissa vest. Other times, she'd wear a pair of cutoffs over her spandex. The layers, I think, were the key to not looking like you'd just walked out of your house in pajamas or that you were Roseanne Barr's long-lost something or other. But we were little kids, and, unlike Melissa Joan Hart, didn't have a wardrobe stylist picking out our clothes. So most of the girls my age would wear their biker shorts with a chic, gigantic Tweety Bird T-shirt. Sometimes the T-shirt would be so big that you couldn't even see the shorts, thus allowing us to achieve that very cute pantsless look.

There was an aerobics craze in the '80s that revolutionized workout clothes—they became a bit cuter and were available in vibrant colors—and all of a sudden, it was acceptable to wear spandex out in public. I think that we were still working through those issues in the '90s and all of the biker shorts seen on elementary school playgrounds and in the halls of middle schools were a by-product of that.

I SCRUNCH, THEREFORE I AM

Invented by Rommy Revson in the '80s, scrunchies were elastic hair ties covered in fabric—the name has to do with the way that the fabric "scrunches" around the elastic band. In the '90s, if you needed to pull your long locks back into a high ponytail à la Stephanie Tanner, a side half-ponytail à la Judy Winslow, or wrap all of it up in a bun à la a

The classy red velvet scrunchie: for formal events.

member of the 1996 Magnificent Seven U.S. Olympic women's gymnastics team, then the scrunchie was your go-to hair accessory.

They came in every possible color and a variety of prints and fabrics, but the velvet scrunchie was by far my favorite. If you were supposed to get fancy for a special occasion, all you had to do was swap your more casual heather-gray cotton scrunchie for one of these. Interestingly, if you were to wear that heather-gray cotton one to a formal event, it would probably have seemed wildly inappropriate. That simple fabric change made a world of difference.

When scrunchies weren't on our heads, they were on our wrists. To quote the female narrator of Goosebumps no. 24, *The Phantom of the Auditorium*, "I always wear a hair scrunchie on each wrist. I like to be prepared. You never know when you're going to need a hair scrunchie." That R. L. Stine, he really knew how to write female characters! So many of us wore our scrunchies this way that the hair ties became an unofficial bracelet. The best thing about them was how multifunctional they were. You could slingshot them across a room for a good time, use them to secure a rolled-up poster, or slip one around your cat's neck to help her look less naked. Despite their versatility, scrunchies slowly began to wane in popularity by the end of the decade.

IN MY OPINIONATION, THE SUN IS GONNA SURELY SHINE . . . BUT THAT'S NOT WHY I'M WEARING THIS HAT

Blossom hats were what we called any cutesy, large-brimmed hat that had a massive flower affixed to the front of it. This wasn't the official name, of course, but the titular character of the NBC sitcom *Blossom*, which aired 1991–1995, wore them frequently, and so they are forever tied to her, much like ALS is tied to Lou Gehrig. And much like ALS, they were a disease.

Blossom Russo was a fashion icon (she and Clarissa Darling were the decade's most stylish teens), and everything that the character wore just seemed infinitely cooler than anything that I owned by virtue of being on her body, even these hideous hats. The character wore them, I think, because of her floral-themed name, but the rest of us had no excuse. They were so big and gaudy that the simple act of putting one on was almost like a commentary on the idea of wearing hats. It was impossible to just nonchalantly have one on your head.

A Blossom hat in laid-back denim.

YOU GO, GIRL

There were some cool clothes to come out of the decade, things that I could very well see myself wearing now unironically—Courtney Love's baby doll dresses, the thigh-high tights of *Clueless*—but as little girls, we were a bit confused. There were no fashion blogs to guide us. We looked at what we saw on TV and tried to adapt it to our lives. Sometimes this worked, more often than not it didn't, but regardless, we worked it.

Thigh-high tights on the *Clueless* VHS cover.

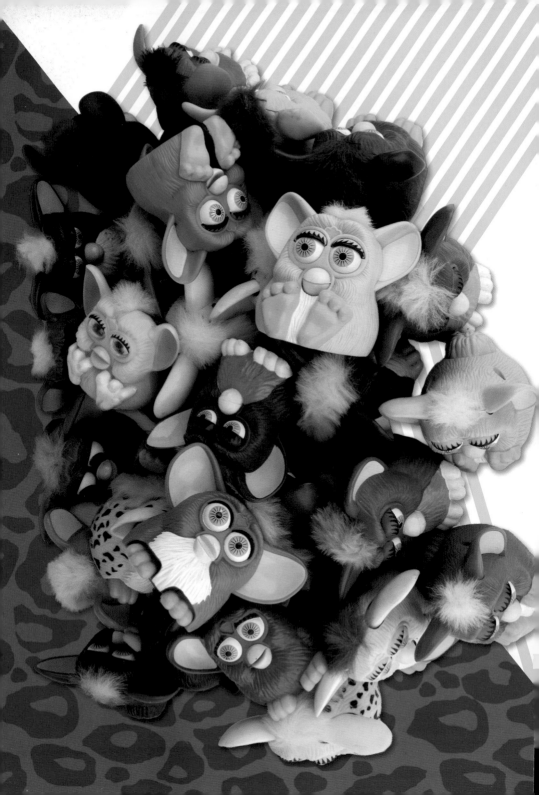

FURBYS

Once upon a time, Furbys lived in the clouds, where they sang, danced, played, and evidently never had to go to work. Bored with their charmed lives, they all gathered around the edge of the "Furbyland cloud," looked down at "the place that Furbys called Earth," and jumped, one by one, because they wanted to hang out with us. This is the Furby origin story detailed in the epic poem printed on the back of every Furby box. It's fifty lines long and, truthfully, puts the *Iliad* to shame. The verses even rhyme (kind of)! Most toys are just toys, but Furbys came with a side of culture.

In 1998, as the Furby frenzy grew, McDonald's began offering three-inch sculpted Furby figurines in Happy Meals. There were eighty variations in all.

MEE-MEE U-TYE

Tiger Electronics introduced the first generation of Furbys in 1998 during the holiday season. There were six different models, all of them practically impossible to come by. The demand for the toy was so great that many people weren't even able to get their hands on a Furby until the next year, when the second generation was released. Of course, the Internet was a thing by this point, so Furbys, which retailed for about thirty-five dollars, were being sold via the World Wide Web by opportunists for three times that amount. Why were Furbys so popular? Well, as the Cabbage Patch Kids craze of the '80s proved, Americans go mad for any toy that walks that fine line between cute and horrifying. A Furby was a six-inch, electronic fur ball—the love child of Gizmo from the Gremlins movies and a Tamagotchi owl—with feet, but no arms, and bulbous, blinking eyes that were the stuff of nightmares. The main draw, though, was that Furbys could learn to speak English.

There were four stages of Furby development. In the first, the Furbys, which were battery powered, only spoke a "magical" (according to the instruction manual) language called "Furbish" that included words like "a-loh may-lah," "noh-lah," and "mee-mee u-tye" (if you've misplaced your Furbish-to-English dictionary, that translates to "cloud," "dance," and "very up"). The second and third stages were, linguistically, kind of like the Furby's toddler years; the Furby could speak a little English, but most of what it said was

Dalmatian, an Adult Generation 2 Furby.

nonsense. In the final stage, the Furby spoke English often but still spoke some Furbish, I guess because it wasn't looking to totally assimilate itself into our culture.

Some people mistakenly believed that Furbys had built-in recorders that made it possible for them to parrot the words that were spoken to them by their owners, but the English vocabulary that the Furby would eventually begin to use was already programmed into the toy. Before the myth was debunked, Furbys were banned from the National Security Agency's premises in Maryland. The NSA was afraid that the toy would start repeating classified information.

Their fur came in a wide array of colors, from gray to neon green. Some had stripes, some had cheetah spots, and one had a whole ladybug motif going on. Beneath that fur were sensors, located on the front and back of their bodies, so you could pet them or tickle their tummies and they would respond to your touch by purring or giggling. There were also preprogrammed games that the two of you could play, like "Ask Furby," where you'd ask it a question, rub its back, and then wait for an answer, which was good for minutes of fun! The Furby's sound sensor could detect when another Furby was speaking, so if you had two Furbys, you would've been able to listen to them talk smack about you in Furbish.

Usually, you have to totally rely on your own imagination to create the interior lives of your stuffed animals, dolls, and action figures. But Furbys cut that work in half. They were alive. Sort of. And if you were looking for a

friend that you could talk to or hug and then throw into the closet once they ceased to entertain you, Furbys were perfect. For a precursor to the artificial intelligence that will one day destroy our civilization, they were pretty fun to play with.

Top and bottom: Mini Furby Happy Meal toys from 1998.

91

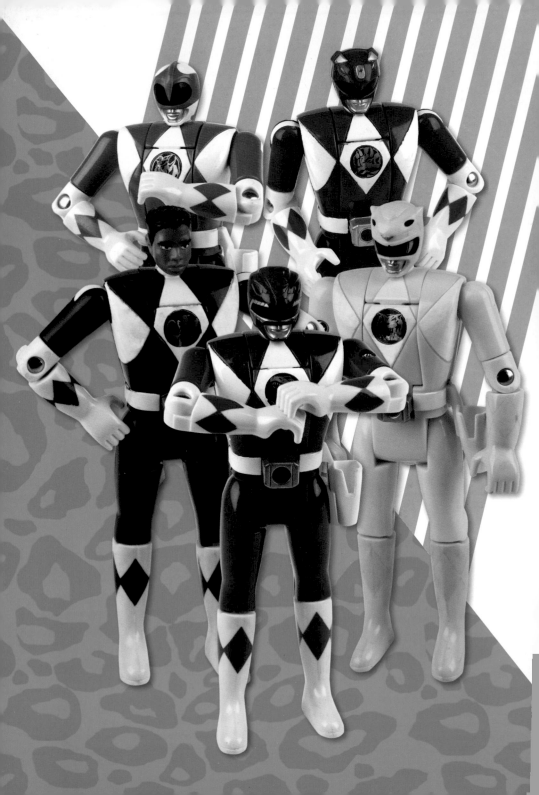

MIGHTY MORPHIN POWER RANGERS

According to the immutable laws of science and all of history's annals, backflips make anything at least 45% better than it would have been sans backflips; perfectly executed tornado kicks improve things by about 37%; and Zords—that is, monstrous robot-fighting machines—well, they'll usually lead to a 52% increase, even more if it's a Megazord, Dragonzord, or a Mega Dragonzord. So, if anyone—including you, in a moment of deep introspection—ever wants to understand the allure of the Mighty Morphin Power Rangers, these figures should help. However, on the qualitative tip, the Power Rangers

Released by Bandai in 1994, the Power Rangers Auto Morphin collection boasted "real morphin action." Pressing a lever on the action figure's torso switched the head from Ranger mode to civilian mode.

were just badass. They wore spandex frequently and unapologetically; when struck by swords or knives, sparks would shoot from their bodies instead of blood; and they had the confidence to use the nonword "morphin" as a verb and an adjective, and, occasionally, to turn it into a totally different and even more audacious nonword like "morphinominal."

THE SETUP

Zack, Trini, Kimberly, Billy, and Jason were your garden variety "teenagers with attitude," chilling at the local youth center/juice bar on the regular as teenagers are wont to do, but all of that changed when wicked space sorceress Rita Repulsa decided to try to conquer the planet. Instead of targeting a city like New York, London, Hong Kong, or Paris, Rita wisely chooses to hit Earth where it will hurt the most: Angel Grove. Rita's plan doesn't sit well with Zordon, an interdimensional, disembodied head (interdimensional, disembodied heads are generally opposed to evil, I'm assuming), so he tells his robot consort Alpha 5 to teleport Zack, Trini, Kimberly, Billy, and Jason to him, for they are to become the Mighty Morphin Power Rangers—an unstoppable force of good with the ability to smoke a bad guy by simply kicking or punching him a couple of times.

Mighty Morphin Power Rangers premiered on the Fox network in 1993. Rather than just borrowing the premise of Japan's popular *Super Sentai* series and adapting it for an American audience, action footage from the source material was actually intercut with footage of the American cast, so half of the show was dubbed (and occasionally featured the lack

of synchronization between sound and lip move-
ments oft-parodied by such comedic luminaries
as that guy from the Police Academy movies).
Power Rangers championed diversity just as much
as it championed explosive fight sequences, and
the Rangers were a veritable microcosm of
society—one was African American,
one was Asian American, two were
girls, and one wore overalls all of
the time. Today we may roll our eyes at
how calculated the casting was, but for kids it was an
important part of the show's success. No matter who
you were, there was a character that you could relate
to, even if it was just superficially, and if this character
on your TV screen that you sort of vaguely had some-
thing in common with could be a Power Ranger, then
certainly you could be one as well.

IT'S MORPHIN TIME

In every episode, Rita would unleash some new
monster on Angel Grove, but she was considerate
enough to do so when the Power Rangers weren't in
class. Once the teens assembled, Jason, the leader of the quin-
tet, would yell out, "It's morphin time," and the "morphin" would
commence. Zack, the cool one (as evidenced by his constant dancing and
constant Hammer pants–wearing) morphed into the Black Ranger; budding
activist Trini became the Yellow Ranger; girly girl Kimberly transformed into the
Pink Ranger; brainy, bespectacled Billy became the Blue Ranger (obviously, for
the sake of alliteration); and beefy but kind Jason was the Red Ranger. Later,

MEGAZORD!

new-kid-in-town Tommy would be added to the crew as the Green Ranger and then, in what was the show's most dramatic story arc, eventually emerge as the White Ranger.

The fighting climaxed with the group calling on their respective Zords—which were giant, robot dinosaurs in the show's first season but would take the form of different creatures in subsequent years—and combine them to create Megazord, an even bigger robot that could have very well been a cousin or possibly a nephew of Voltron's. Any adults who thought that the Power Rangers were merely encouraging the nation's youth to kick things need only consider this Megazord, which symbolized teamwork and showed kids that people from different backgrounds could come together as one to combat evil eyeball monsters. Of course, I don't know that we totally grasped that message. I certainly didn't. When I used to "play Power Rangers" with my neighbor, I was the Yellow Ranger, he was the Black Ranger, and we almost reflexively fought each other.

THE TOYS

The wait between episodes could be unbearable for hard-core fans, so the Power Ranger toys offered a modicum of comfort in the intervening days. The eight-inch action figures towered over Ninja Turtles and were big enough to be cradled by nurturing types. I don't know if Bandai, the company that produced the toys, was going for gender neutrality with the line or if they simply didn't think anyone would care, but the original female Power Ranger

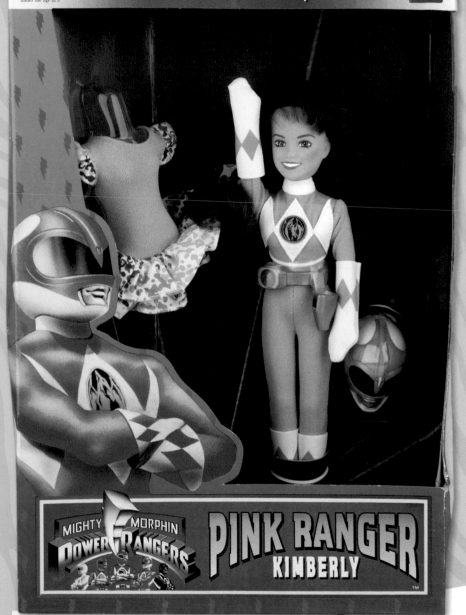

Kimberly's girlier incarnation with brushable hair, circa 1994.

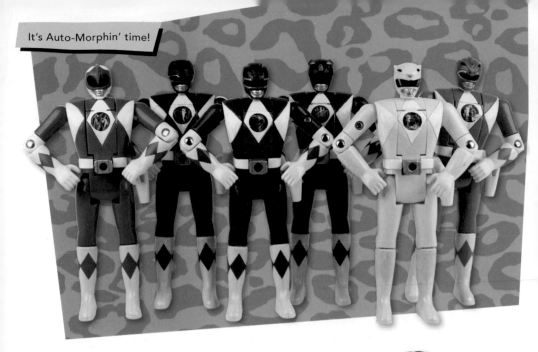

action figures had the same brawny build as the males. Even worse, you couldn't brush their hair, which I'm sure aggravated most girls.

This problem was rectified in a way with the release of Kimberly and Trini dolls. Their physiques were decidedly more feminine and they had thick, brushable locks. The boxes that they were packaged in had "Power Rangers for Girls" printed on the front of them to ensure that boys didn't mistake these for toys that they could play with. Some might say that the Megazord was the premier Power Rangers toy because it could be disassembled into five toys, but I'd have to go with these dolls. In addition to the traditional Ranger spandex, Kimberly and Trini each came with a cute casual outfit, and there's really no beating that.

GO GO POWER RANGERS

Mighty Morphin Power Rangers aired until 1995, and a movie based on the series hit theaters that same year. The obsession with this teenage fighting force reached its pinnacle around this time and, across the country, tiny Power Rangers patrolled the streets on Halloween. When the original series ended, it was followed by *Power Rangers Zeo*, then *Power Rangers Turbo*, and then several other iterations of the franchise that I was far too pubescent to pay much attention to. By the time I was in middle school, all of the things that I had once thought were great about the show—blowing into a dagger and playing it like a flute, the pointless gesticulation accompanied by air-swiping sound effects—just seemed cheesy. That sudden realization that you've been frittering your life away on the Power Rangers is like an unofficial coming-of-age moment that I know many of us have experienced. You'd think that if our parents had really loved us, they would've staged an intervention and confronted us about our morphin addiction.

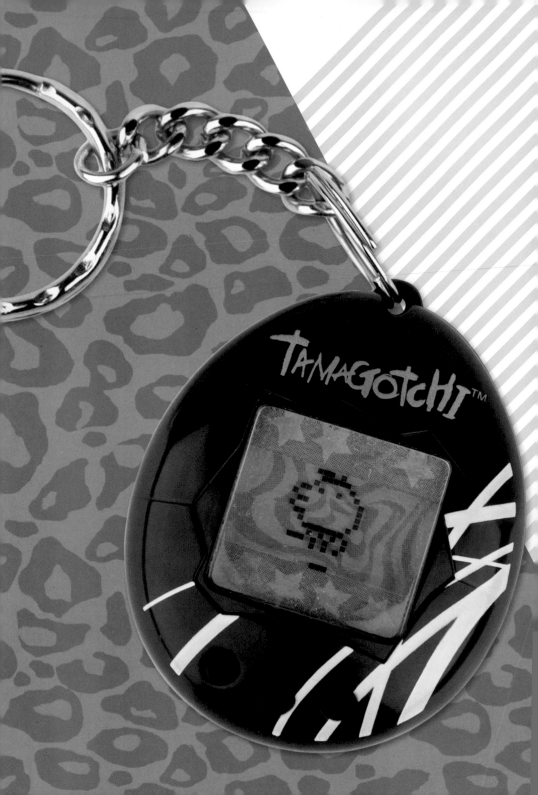

TAMAGOTCHI

I wouldn't be surprised if we're all lab rats in some large-scale science experiment that Japan is conducting. Their brilliant scientists are working around the clock, coming up with new asinine electronics in cute packaging, curious to see what our response will be once they introduce this new stimulus into our lives. Will they realize how absurd the toy is, or will they allow it to take over their lives? I bet they got some interesting results from their Tamagotchi studies.

 A Generation Two Tamagotchi virtual pet, circa 1997. In this second release, the egg-shaped key chains were available in a wider range of colors and designs.

The cutest poop in the world.

CONGRATULATIONS, IT'S A TAMAGOTCHI!

Tamagotchis turned playtime into a chore. They were digital pets that you were supposed to take care of by feeding them, playing with them, monitoring their health, and even cleaning up their poop. Yes, poop. It was shaped like a tiny, pixilated Hershey's Kiss, which meant that it was the cutest poop in the world.

The Tamagotchi's backstory: it was an alien who'd traveled from its home planet to learn about Earth. The device that housed this alien anthropologist was an egg-shaped plastic key chain with three buttons and a built-in LCD screen. Your new pet started life as a simplistically rendered egg graphic on the screen. Five minutes later, it hatched and shit got real.

In this infant stage, the Tamagotchi took the form of a circle with two dots for eyes and a dash for a mouth. To help your pet grow up well, you had to tend to its needs. Whenever it wanted something, the device beeped, just like a real pet.

There were four hearts on the "Happy" and "Hunger" meters. If all of the hearts were filled in, then your Tamagotchi was fine, but if, say, only one heart was filled in on the "Happy" meter, then you'd have to figure out how to improve the Tamagotchi's mood. You could give it a loaf of digital bread by using the three buttons beneath the LCD screen to navigate to the "fork and knife" icon or play with it by navigating to the "bat and ball" icon. Once the hearts were filled in, you could go about your day, no longer beholden to the toy . . . for the moment.

One day equaled one year in Tamagotchi time, and what they looked like as they aged was determined by how well you took care of them. My Tamagotchis always ended up looking like sperm—the body was a circle with a tail attached. I'm no expert, but I'd say that's the form they took when they

were being neglected. No pet that's being nurtured properly should ever look like a single-celled organism for that long.

An ominous black skull appeared above the Tamagotchi's head when it was sick. Navigating to the syringe icon allowed you to administer the lifesaving antidote. When your Tamagotchi was ready to go to sleep (a "Z" would appear above its head), you had to turn off the lights (by selecting the light-

bulb icon) or else it would become "restless." And no one wants a restless Tamagotchi.

Sometimes your Tamagotchi would fall into a funk. The hearts on its "Happy" and "Hunger" meters weren't filled in, but it would refuse to eat or play. It was during these moments that you were required to select the "discipline" icon. Although, I think that it should have been a "therapy" icon, because the Tamagotchi was depressed and didn't need to be scolded; it needed to vent.

Taking care of a Tamagotchi was a never-ending duty, so you couldn't just leave it unattended. Kids were trying to be responsible and do right by their digital pets by bringing them to school—Tamagotchis could die from neglect!—but the device would beep in the middle of class and end up being confiscated and put in a teacher's desk drawer, where the Tamagotchi would surely meet its end.

I don't know that anyone felt an emotional connection to those pixels, but the game made the idea of being the perfect caretaker desirable. I'm sure that the practice we got from Tamagotchis will serve our aging parents well in the future.

The end is near.

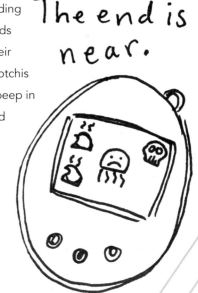

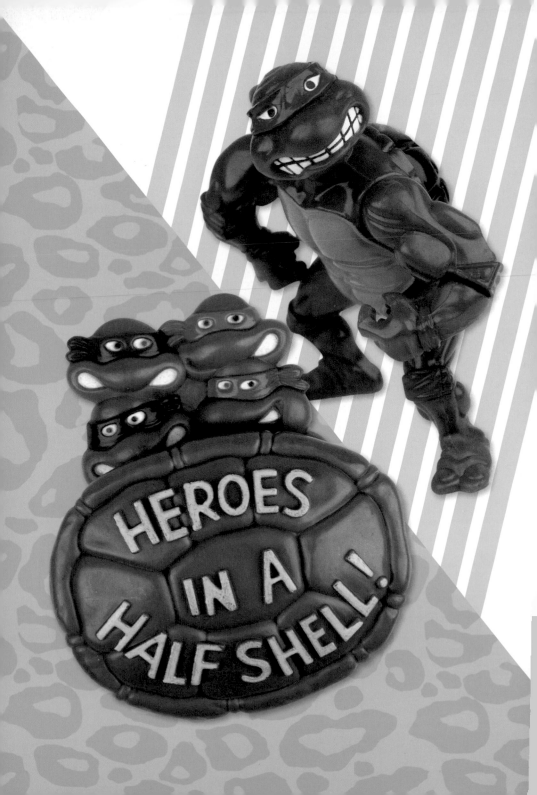

TEENAGE MUTANT NINJA
TURTLES

The most traumatic moment in my young life was when an idiotic
girl mistook my backpack for hers and gave everything inside it
to the other kids in our day care, evidently thinking that someone
had stuffed her bag full of their belongings and not that the bag might
not actually be hers. This wouldn't have been so bad if I just had papers
and crayons inside the bag, but it contained half of the Ninja Turtle
action figures that I owned. You're probably saying, "If that's the most
traumatic thing that happened to you, then you must have had a pretty
charmed childhood." To which I say, shut up. You don't know how much I
loved those turtles.

 The original Donatello action figure manufactured by Playmates Toys
and a "heroes in a half shell" belt buckle that would have made you
the envy of everyone on the playground: the Turtles' heads slide up
and down behind the shell.

HEROES IN A HALF SHELL: THE TMNT STORY

Because the Teenage Mutant Ninja Turtles have been presented to us in a few different forms—Kevin Eastman and Peter Laird's original 1984 comic book, multiple cartoon-series incarnations, four movies, etc.—the origin story varies. But in all versions (so far), the ninja turtles and Splinter, their rat mentor/adoptive father, transformed into humanoid martial artists after a canister of mutagen ooze was poured into the sewer where they were living.

In the animated series that was broadcast from 1987 to 1996—the avenue that introduced most people of my generation to the franchise—Splinter, formerly a human ninja master named Hamato Yoshi, had taken up residence in a New York sewer. His only friends were rats and four baby turtles that had accidently been dropped down there. When the mutagen fell into the sewer, it covered the tiny reptiles, turning them into humanoid turtles because Yoshi had touched them and he was human and that's how ooze works (duh!). Yoshi touched a rat after he'd touched the ooze on the turtles and, per ooze rules, he turned into a rat man.

The 1990 live-action film and comic versions of this story make a little more sense, as the rat that turned into Splinter started out as a rat who'd learned ninjitsu by mimicking his former owner Yoshi (I said a *little* bit more sense). The ooze therefore caused the same reaction in him and the turtles. To me, this better explains why the turtles were calling him Splinter and not Yoshi. If you mutated into a rat, would you just, out of the blue, decide to start

Splinter action figure, going back to 1988.

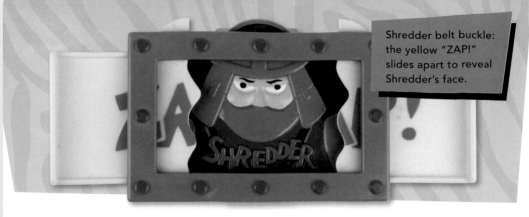

making people call you Splinter or would you go by your real name? I'll let you ponder that one.

As the turtles grew into teenagers, Splinter taught them ninjitsu—but not before naming them after Italian Renaissance painters. Leonardo, who wore a blue mask, was the even-tempered leader, wielding two katana swords. Donatello (the sexy one), who wore a purple mask, "does machines," according to the cartoon's theme song. His weapon was the bō staff. Raphael, the prick of the group, wore red. He carried two sai. Finally, Michelangelo, who used nunchucks, wore orange and was the "party dude." When they weren't fighting the evil Shredder or alien brain–guy Krang, they were eating pizza and saying, "cowabunga, dude," because they were teenagers and that's what teenagers do.

THE TOYS

The Teenage Mutant Ninja Turtles action figures were to the '90s what the He-Man action figures were to the '80s: everyone had them and they totally misrepresented what arm and leg muscles look like. Before the show's inception, the comic book's creators, Eastman and Laird, approached Playmates Toys about manufacturing action figures based on their work. Playmates was reluctant and didn't end up making the deal until the cartoon was greenlighted.

The first Ninja Turtles toys that I had were naked, save for their masks, belts, weapons, knee scarves (that serve no purpose, as far as I can tell),

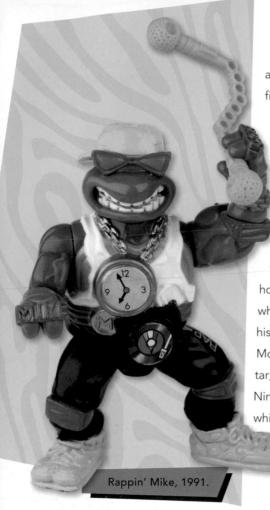
Rappin' Mike, 1991.

and, of course, half shells. New figures would give the turtles different ensembles and personas that weren't related to the cartoon at all but were necessary if Playmates wanted to continue to make money. This meant that eventually your collection might have grown to include "Slapshot Leo," who wore a hockey jersey and came with a hockey stick and pucks; "Rappin' Mike," who wore a big Flava Flav clock around his neck; "Punker Don," who had a Mohawk and an authentic punk rock key-tar; or "Ralph the Green Teen Beret." The Ninja Turtles' allies (like Usagi Yojimbo, a white samurai rabbit created by comics artist Stan Sakai who appeared in two crossover episodes of the '80s cartoon series; Casey Jones, the hockey-masked human vigilante who always kept it casual in a pair of sweats; TV news reporter April O'Neil; and Splinter) as well as bad guys (like Shredder, Krang/Krang's Android Body, Cajun gator Leatherhead, and Rat King) were also available.

Accessories provided your imaginary battles with some context. I had the Sewer Playset, which was described as a "double-decker hangout and hideout for Turtles," but really, it was a dollhouse—let's not kid ourselves. It had two compartments—a "sewer control center" and a "wreck-reation room"—made to look sewer-y with ooze and garbage stickers, and a working elevator that

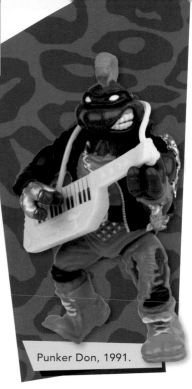

Punker Don, 1991.

took whichever figure you put onto the platform up to a street-level scene. I assembled it once, but because I couldn't have this large dollhouse in the middle of my room without tripping over it, I had to take it apart, and I never played with it again.

The Pizza Thrower Assault Vehicle was a cross between a tank and an oven. It launched small plastic pizza discs via a battery-powered mechanism and it could knock over your Shredder action figure or any other bad guys that you had lined up. But within the show's reality, that toy didn't make any sense. There's no way the Ninja Turtles would've wasted that much pizza.

TURTLE POWER

Three live-action Ninja Turtle films were released between 1990 and 1993, but none of them answered any of our pressing questions about the world's most fearsome fighting team. Whenever they went out in public during the day they'd disguise themselves with trench coats and fedoras. How did that work? They were still green and had turtle faces and green turtle feet! But the major question was, were they ever going to become Twentysomething Ninja Turtles?

A classic Raphael figure.

LEONARDO
1st DEGREE NINJA

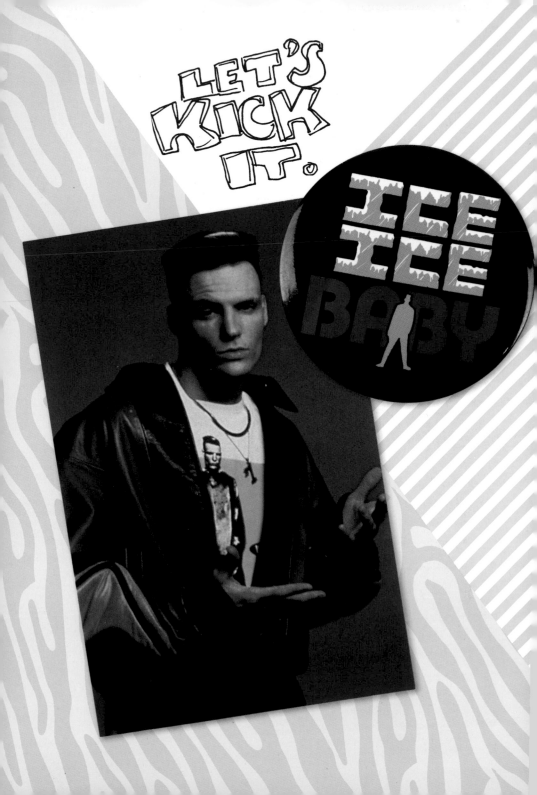

VANILLA ICE

anilla Ice was a white rapper who wore harem pants and, once, a metallic jacket with "word to your mother" bedazzled onto the back of it. I could probably stop there and you'd have all of the information required to understand who he was, but I'll continue anyway.

★ The title of Vanilla Ice's chart-topping hit emblazoned on a button and the rapper wearing a Vanilla Ice T-shirt—he was so meta. The po-mo portrait and the card on the right were postcards that came with the Vanilla Ice doll.

STOP, COLLABORATE, AND LISTEN

Born Robert Van Winkle, Vanilla Ice running-manned his way to the top of the Billboard music charts in 1990—he was the first rap artist to have a single reach number one. The song in question, "Ice Ice Baby," offered us all a glimpse into Mr. Ice's astonishing, often harrowing existence. Cooking MCs as one might cook bacon, going crazy whenever cymbals were played: such was the life of Vanilla Ice.

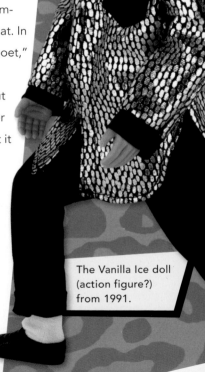

Adults, and anyone who was listening to actual hip-hop music at the time, had a handle on how ridiculous Vanilla Ice was and likely saw him for the flash in the pan that he would ultimately end up being. But he was a legitimate rapper to many young people, and his flamboyant lamé ensembles weren't at odds with that. In "Ice Ice Baby" he'd said that he was a "lyrical poet," and verses like "I flow like a harpoon daily and nightly" tended to support that claim. His debut album, *To the Extreme*, remained at the number one spot for a staggering sixteen weeks. To put it another way, for sixteen weeks, no one could come up with anything better than "Ice Ice, baby, too cold, too cold."

Vanilla Ice had no credibility with the hip-hop community, not because he was white, but because he was inauthentic and basically a joke. Middle America, however, loved him,

The Vanilla Ice doll (action figure?) from 1991.

so his managers packaged for the masses. In the early '90s, he was in the same teenybopper magazines as the New Kids on the Block.

The Vanilla Ice doll was the next logical step, and though it could have mixed right in there with all of your Kens and Barbies, the kid pictured on the back of the box playing with it was a boy. The doll had poseable legs that, according to the photos on the box, could be bent to make it look like it was doing lunges or lifting its knee in the air, both of which I'd qualify as action maneuvers. But it was wearing a gold sequined top and the box it came in was pink. So: Action figure? Doll? I'd say it's a toss-up.

GO, NINJA, GO, NINJA, GO

Vanilla Ice fell out of favor quickly. His may even be the fastest decline for someone as successful as he initially was in music history. It's hard for me to find too much fault with him, though, because if he hadn't been around, and hadn't had this all-consuming drive to make tons and tons of money, "Ninja Rap" from the *Teenage Mutant Ninja Turtles II: The Secret of the Ooze* soundtrack might not have existed. And I don't even want to imagine a world without that song.

MC Hammer

It was MC Hammer, that "super dope home-boy from the Oak town," who'd popular-ized the harem pants that Vanilla Ice was so fond of. *Please Hammer, Don't Hurt 'Em*, MC Hammer's first mainstream record, was released in 1990 and featured "U Can't Touch This," probably the artist's big-gest hit. In the photograph of him on the album cover, he's wearing a very dapper suit, glasses, and a pocket square. This image is in stark contrast to the photo-graph on his next album, *Too Legit to Quit*, where he is shown in a much more casual waist-high pants/suspenders/topless look. MC Hammer (later changed to the pithier "Hammer") would later provide the theme song for the Addams Family movie, become a cartoon character on the Saturday Morning Cartoon *Hammerman*, and be forever immortalized in plastic form with the MC Hammer doll (so many additional outfits to buy!).

HOME ALONE

In the '80s, John Hughes wrote *The Breakfast Club*, *Sixteen Candles*, and *Pretty in Pink*—all were movies that would come to define a generation. But in the '90s, he really devoted himself to coming up with the perfect cinematic articulation of the highs and lows of youth when he wrote *Home Alone*.

Home Alone was released on VHS in 1991, making it possible to watch the movie while you were actually home alone.

THE MOVIES

How much could the McCallisters actually have loved Kevin? In 1991's *Home Alone*, they "accidentally" left him behind while they went to France for Christmas. Fortunately, Kevin was intrepid enough to defend himself against a duo of robbers trying to break into the house. In 1992's *Home Alone 2: Lost in New York*, the family, running late for a flight, got separated from Kevin and didn't realize it until they landed in Florida and Kevin got on a plane to New York. None of us watching these movies questioned this, because the McCallisters' neglectfulness and apparent hatred of their young son gave us the chance to watch Macaulay Culkin outsmart adults, thrive on his own, and eat plain cheese pizzas. He handled the threatening situations he found himself in the exact same way that we were sure we would have. Kevin empowered kids.

THE TALKING KEVIN DOLL

There were two Kevin dolls released after the first movie. Both made me upset. One was a plastic nine-inch doll that screamed; the other was seventeen inches with a plush body and a plastic head. It had a pull string and said classic Kevinisms like, "Do you guys give up, or are you thirsty for more?" and "Aaaaah!" What bothered me was that the clothes they were wearing were inaccurate. The red shirts didn't look anything like the sweater that Kevin wore in *Home Alone*. At seven years old, I had my mother take me to the local craft store, purchase some burgundy fabric that I thought resembled Kevin's sweater more closely, and teach

The screaming Kevin doll, 1991.

116

me how to sew a little so that I could make the doll a new shirt.

The Talkboy tape recorder, inspired by *Home Alone 2*.

THE TALKBOY

Everyone wanted a Talkboy after we saw Kevin use the device in 1992's *Home Alone 2*, which was created just for the movie at first. The handheld tape recorder came with one cassette. It had "speed control," so after you'd recorded yourself talking, you could speed up or slow down the playback, changing the sound of your voice. The first Talkboy was the same silver color as Kevin's, but a pink Talkgirl was released because girls don't like to play with toys that aren't pink. The novelty of having this working piece of memorabilia wore off fast because ultimately it was just a tape recorder.

HOME ALONE: THE NEXT GENERATION

One day I overheard a little boy talking to his dad at the video store where I used to work. The kid was excited because he'd found *Home Alone* and *Home Alone 2*. Up until that point, he'd known only about *Home Alone 3* and *Home Alone 4* (movies that had later been issued to capitalize on the franchise's success but didn't include any of the original actors). The kid said he didn't know that there were two movies that came before the ones he'd seen. Once a sign of our youth, having watched *Home Alone* when it was released is now a sign of how much we've aged. And also a sign that that kid needs to spend more time studying and less time watching *Home Alone* sequels. Did he really think that the first movie was called *Home Alone 3*?

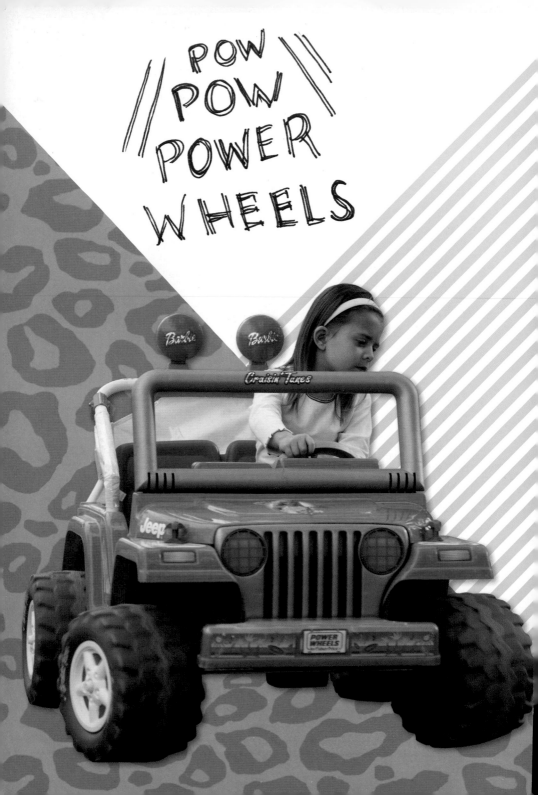

POWER WHEELS

I don't drive. If you were to press the issue, you would discover that the reason I don't drive is because I *can't* drive. I had a learner's permit and nearly drove my mother's car off the fourth level of a parking structure. I'd made that basic person-who-has-no business-behind-the-wheel mistake of pressing the gas instead of the brake. Fortunately, my foot, totally independent of my brain, was able to locate the appropriate pedal just in time. Coming so close to unintentionally reenacting the ending of *Thelma & Louise*, though, was enough to put me off driving indefinitely. And sitting in puddles of indeterminate liquids while riding

The spacious Barbie Jeep Power Wheel was targeted at girls, but the pink paint job probably wouldn't have stopped a boy from driving the battery-operated toy car.

public transportation hasn't changed that. The only way that I'll ever reevaluate this decision is if car manufacturers develop an acceleration system that is as intuitive as the one in the Barbie Lamborghini Power Wheels—put your foot on the pedal and you go forward; take your foot off the pedal and you stop. Or, alternatively, if like the Barbie Lambo, they make it so that it's possible to just step out of the top of the car when the need arises.

POW-POW POWER WHEELS

Kids want to do the things that adults do. They want to cook and wipe poop off a baby's butt. That's why we have toys like the Easy-Bake Oven and Baby Alive. However, if you were to take a survey of a group of youngsters, ages two to seven, and ask them which adult activity they thought looked like the most fun, at first they'd almost certainly give you some weird answer that didn't make sense, like "pencils," but then if you were patient, the answer would probably end up being driving. And I'd say that that goes for both girls and boys.

Power Wheels allowed kids to "drive for real" in mini, child-sized vehicles. The cars ran on batteries (so they were eco-friendly if you happened to be a baby environmentalist) and went up to about five miles per hour. They really did look like shrunken-down versions of actual cars and some were even modeled after Jeep, Porsche, and Lamborghini brands. For the sake of authenticity, there were realistic play features (meaning they didn't actually work) like windshield wipers and car phones. However, there were also functional features like doors that opened and shut. The ability to close a door doesn't sound too thrilling, but there was something about doing it

A pink Mercedes can probably still make you shed tears of joy.

that made you feel mature, like you were taking care of business.

Power Wheels originated in the mid-'80s, but by 1990, one million were being sold a year. New models were coming out all the time and by the end of the decade there was a Power Wheels vehicle to suit every personality. For the adventurous types there was the Kawasaki quad bike, for the slightly smaller adventurous types there was the Mickey Mobile—a little red motorcycle for toddlers—and for the

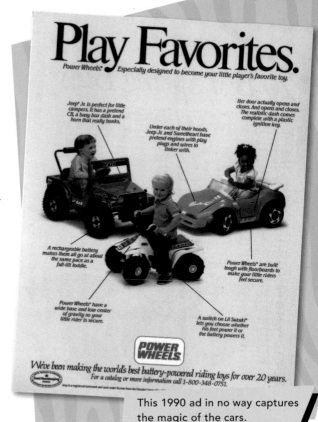

This 1990 ad in no way captures the magic of the cars.

Barbie types there was the aforementioned Barbie Lambo, the Barbie Beach Patrol Jeep, and the Barbie Beach Buggy (which wasn't too different from the Barbie Beach Patrol Jeep), among others. If your parents bought you one for Christmas or your birthday, chances are it was hidden somewhere to be opened last lest it eclipse all of your other gifts.

But then you got older, bigger, longer and your body betrayed your desire to tool around your 'hood in your Barbie Corvette. Power Wheels are recommended for ages two to seven, and while that's usually just a guideline, size issues made age seven the actual cutoff for a lot of us, which is sad because, unlike most toys, which you end up outgrowing, this one didn't lose any of its appeal.

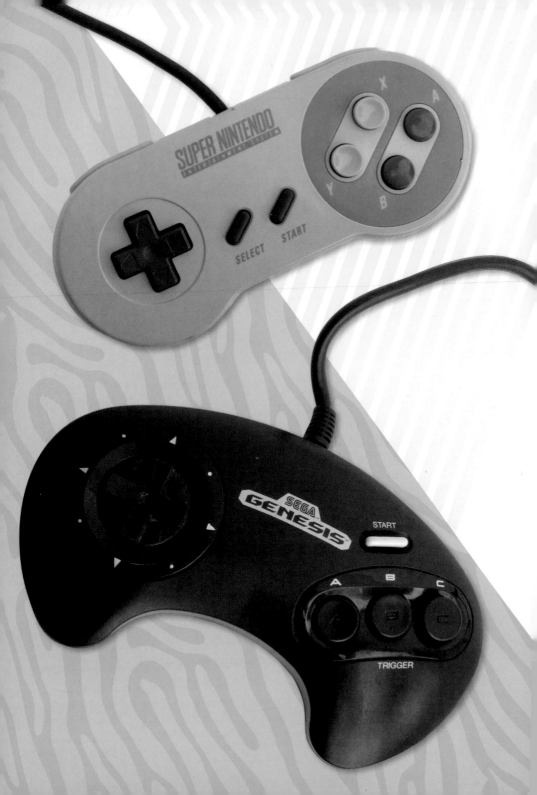

SUPER NINTENDO
VS.
SEGA GENESIS

S uper Nintendo Entertainment System and Sega Genesis were the two major video game consoles for the first half of the decade (released in North America in 1991 and 1989 respectively). They were 16-bit systems, but I don't think most of us fully understood what that meant at the time. When it came to Super Nintendo, all I knew was that "super" was in front of "Nintendo," so it was probably going to be better than the regular Nintendo, and Sega Genesis had the word "genesis" on the end of it, and to me that sounded futuristic (I obviously

Game controllers featured more action buttons than the previous generations. The Sega Genesis, according to its advertising campaign, "does what Nintendon't."

wasn't too familiar with the Bible or dictionaries at this point in my life). On the most basic level, the actual difference between these next-generation consoles and the ones that had come before was that the sound and graphics had improved.

CONSOLE WAR

But between the two, Super Nintendo and Sega Genesis, which was better? Set next to each other, the Super Nintendo might look a bit hokey, all gray and purple, while the Sega Genesis was black and Darth Vader-y. Like America's political party system, we had a two–video game system . . . system. The Super Nintendo and Sega Genesis commercials were even a bit like political campaign ads back then, with Genesis playing dirty—they referred to Nintendo as "Nintendon't." If you had a preference between Super Nintendo and Sega Genesis, then it was likely based on the console's game exclusives. *ToeJam & Earl*, released in 1991, was a quirky game about two "highly funky" aliens from the planet Funkotron. ToeJam was a red, three-legged dude who wore a backward cap and a gold chain, and Earl was his portly orange buddy. It was my favorite game and because it

ToeJam & Earl, 1991.

was available only for Sega Genesis, I preferred Sega Genesis. But I was also opposed to Nintendo on moral grounds. In 1990's *Super Mario World*, probably the most popular Nintendo exclusive and a sentimental favorite among

gamers today, Mario, the plumber who rarely plumbs, meets a young dinosaur named Yoshi, whom he proceeds to ride like a horse without first asking permission. Mario was also way too big to be riding Yoshi—they were the same height! That had to be some kind of dinosaur-rights violation.

THE AFTERMATH

The Super Nintendo and Sega Genesis power struggle foreshadowed the current and future state of video game affairs. There wasn't going to be another Nintendo that we all just owned and played casually. You were either going to have to make a decision about which system you wanted to have, or you were going to have to have enough money to buy all of them, or you were going to start thinking that this was all getting a bit ridiculous and stop playing video games altogether.

Nintendo Game Boy vs. Sega Game Gear

The battle for console supremacy extended to the handheld realm. The Game Boy was released in 1989, and if you wanted to fit shapes next to other shapes while Russian music played in the background, then this was what you were going to want to stick to. The Sega Game Gear hit store shelves in 1991 and it blew the Game Boy away in a couple of different ways. The LCD screen was backlit so you could play it in the dark, and it was featured prominently in the movie *Surf Ninjas*, but the most significant difference was that the graphics were in color as opposed to Game Boy's black and olive. Unfortunately, the Game Gear drained batteries quickly.

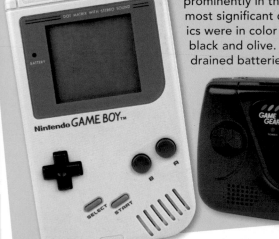

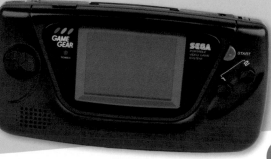

SAVED BY THE BELL

Zack Morris didn't need gel or mousse or any of the styling products that we lesser beings use on our hair. His impossibly fly, SoCal prepster coiffure was held in place with charisma, which oozed from his follicles, pores, and every other orifice on his body. Zack was a schemer, a rascal, a rogue. He could use subliminal messages to get you to go on a date with him, have you kicked out of driver's ed to prevent you from getting your license before him, use photos of you in your swimsuit (that were skeevishly taken without your permission) to

Tiger's twelve-inch Jesse Spano and Samuel "Screech" Powers poseable dolls managed to look nothing like the characters they were modeled after.

make a "girls of Bayside calendar," and you'd forgive him every time. But the greatest trick that this blond, fourth wall–breaking devil ever pulled was convincing the world that he was simply cool and charming when he was actually a minor deity. Zack could freeze time by calling a time-out, he had a two-pound brick of a cell phone that he always seemed to carry with him but which mysteriously didn't bulge out of his pocket, and everything that happened in Bayside High and its environs revolved around him. With a sly smirk and the ever-so-stylish rolled-up sleeves of his denim button-down shirts, the divine Zack Morris cast a spell on us, making it impossible not to watch the shenanigans he got into every Saturday morning on *Saved by the Bell*.

FOR WHOM THE BELL SAVES

Before being retooled by NBC and transformed into the high jinks–heavy teen sitcom that we all hold so dear, *Saved by the Bell* was called *Good Morning, Miss Bliss*. Airing on the Disney Channel, the ill-fated original version of the series focused as much on the travails of the titular junior high school teacher as it did on the students and was set in Indianapolis, Indiana. Mischievous Zack Morris, his nerdy buddy Samuel "Screech" Powers, superficial rich girl Lisa Turtle, and affable principal Mr. Belding were the only characters to survive the reboot, in which Zack became the protagonist and the action moved, without explanation, to Bayside High in Southern California. Added to the cast of the newly redubbed *Saved by the Bell* were Kelly Kapowski, a sweet, all-American cheerleader and Zack's primary love interest; Jessie Spano, a tall,

Saved by the Bell buttons for your JanSport backpack.

overachieving feminist; and transfer student A. C. Slater, a jock with a curly mullet who was Zack's sometime rival.

Originally broadcast from 1989 to 1993, *Saved by the Bell* was Saturday morning's top-rated series. Every so often the show would present viewers with some heavy-handed episode about the dangers of drugs or underage drinking, but it mostly chronicled the zany adventures, dilemmas, and schemes of Zack and his gang. These guys were so cool, beloved, and vital to the lives of everyone around them that they had their pick of any booth at the Max (your standard diner operated by a magician and exclusively patronized by teenagers), despite only ever ordering sodas that they never paid for; were the stars of the school play; wrote the school song; and were occasionally asked by Mr. Belding to do favors for him. Enjoying *Saved by the Bell* was completely dependent upon suspending disbelief, which is probably why it was panned by critics. Kids, however, were able to overlook all of the show's more preposterous attributes and revel in the fantasy of Bayside, which was a dream school located in idyllic California, where the students did things like start a relationship advice hotline and participate in a dance contest hosted by Casey Kasem. A *Saved by the Bell* board game (where the objective was to go on dates with Zack and Slater), a comic book published by Harvey Comics, and dolls modeled after the gang allowed fans to bring a tiny piece of that Bayside magic home and live out their *Saved by the Bell* daydreams.

the Max

After the show's finale, *Saved by the Bell: The College Years*, a series about the post-graduation exploits of Zack, Kelly, Screech, and Slater, and *Saved by the Bell: The New Class*, which saw a new group of popular teens running Bayside, followed. Neither had the same kind of cultural impact as the original. A TV movie, *Saved by the Bell: Wedding in Las Vegas*, reunited every member of the Bayside six and ended with Zack and Kelly getting married—a satisfying conclusion to the greatest love story of the '90s.

FRIENDS FOREVER

If I were to say, "I'm so excited, I'm so excited, I'm so . . . scared" to almost anyone born between the years 1979 and 1986 who had a TV growing up, that person would immediately know that I was referring to the time that

Jessie got hooked on caffeine pills. This same person would also know the chorus to The Zack Attack's hit single "Friends Forever" and probably be more familiar with Bayside High's "beat buh-beat buh buh buh beat, beat-buh beat buh buh buh beat Go Bayside!" cheer than his or her own alma mater's fight song. We could reminisce about the time that Kelly's face turned maroon after using the zit cream Zack gave her, or the month or so during senior year when leather-clad new girl Tori showed up and Jessie and Kelly disappeared without any of the original members of the gang ever talking about how weird that was. Bayside High may have been

a fictional school, but everything that happened within its hallowed halls and that one first-floor classroom where every subject seemed to be taught left a very real imprint on our hearts.

Parker Lewis: The Prime-Time Zack Morris

Parker Lewis Can't Lose aired Sunday nights on Fox from 1990 to 1993. Like Zack Morris, the show's title character was a slick teen, seemingly fashioned after Ferris Bueller, who ruled his California high school.

Parker, though, wasn't popular in the classical sense. He had his buds, but he transcended cliques and was known and loved by everyone at Santo Domingo High for his ability to provide them with the things they needed (candy, Tom Petty tickets, a *Pump Up the Volume*–esque pirate radio station).

So who would be the victor in a cool-guy showdown? Parker or Zack? Neither. It's a trick question. Since their respective universes revolved around them, if the two even met, it would lead to disastrous hemispheric change. As any astronomer will tell you, Earth is able to maintain its approximate 23-degree axial tilt only because Parker Lewis and Zack Morris have never crossed paths.

GENTLEMEN, SYNCHRONIZE SWATCHES!

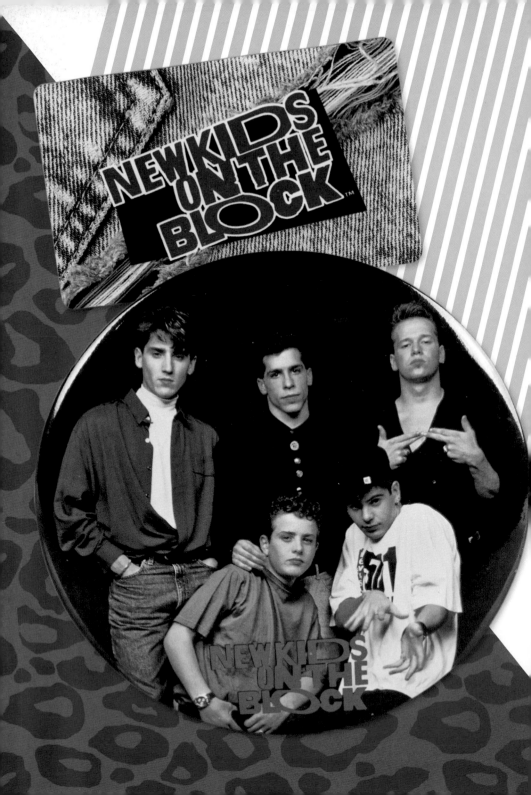

NEW KIDS ON THE BLOCK & BOY BANDS

Whenever I see footage of tween girls sobbing uncontrollably at a live performance of some fresh-scrubbed pop star, I get kind of uncomfortable, not only because these otherwise regular-looking girls have totally bypassed fanaticism and are hurtling toward insanity, but because I can, on some level, empathize with this kind of mania. When I was in elementary school, I used to kiss a framed picture of New Kids on the Block's Jordan Knight before I went to sleep. I also

 A card from Milton Bradley's New Kids on the Block game and a button illustrating just how fly the New Kids were.

had a New Kids nightgown, socks, a jacket and, yes, even marbles. Obsessing over the New Kids was not something that I decided to do—I was helpless to resist the group's power over me.

Jonathan

YOU GOT THE RIGHT STUFF

The music video for 1990's "Step by Step" opens in black and white. So right off the bat, you know you're dealing with a group of classy guys. Each one of the boys stands behind a microphone, performing a choreographed dance full of gyrating hips and variations on the running man.

Jordan

Millions of other seven-year-old girls watching the video may have thought that the boys were singing to them, but they were actually singing to me, telling me that they "really wanted me in their world," and I knew they meant it because they were so forthcoming with the "ooh babies."

Joey

Leather-clad Donnie Wahlberg, braided-rattail aficionado Danny Wood, little Joey McIntyre, and brothers Jordan and Jonathan Knight were the New Kids on the Block. The Boston-based teen singing group was cultivated in the '80s by Maurice Starr (who'd formerly worked with New Edition). Though they'd released an earlier self-titled album, it wasn't until 1989's *Hangin' Tough* that

they achieved success. While fans liked the group as a unit, there was always one member that you gravitated toward. That person was rarely Donnie and never Danny.

But did you know that Frank Sinatra was Joey's favorite singer? Or that Jordan's full name is Jordan Nathaniel Marcel Knight? Or that all of the New Kids loved to play sports? Well you would if you had the New Kids on the Block collectible cards and read any of the interviews found in *Tiger Beat*, *Bop*, or *Big Bopper* magazines in 1992.

Danny

Donnie

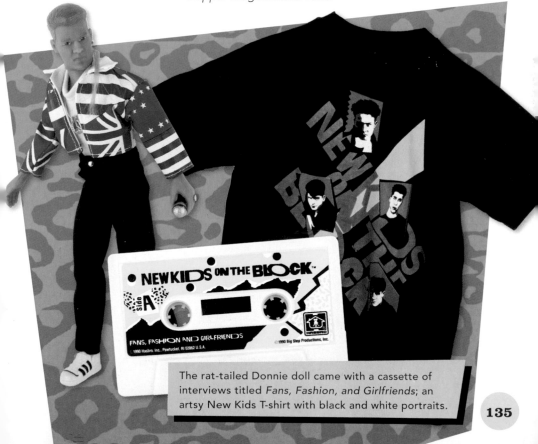

The rat-tailed Donnie doll came with a cassette of interviews titled *Fans, Fashion, and Girlfriends*; an artsy New Kids T-shirt with black and white portraits.

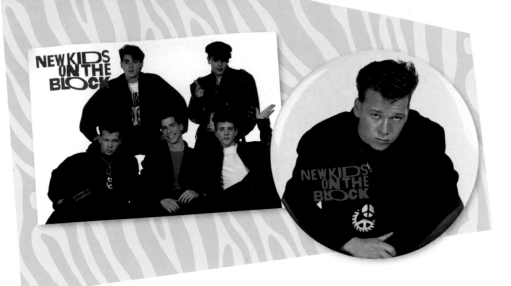

The music was almost incidental. New Kids fandom was all about staring at pictures, watching their Saturday morning cartoon *New Kids on the Block*, and wearing T-shirts or buttons that had their faces all over them. Playing with the dolls, studying their biographies—it was all done in an effort to achieve some kind of closeness. We couldn't actually touch them or interact with them, so the only way to deal with that desire and enthusiasm was to fixate on them. The New Kids weren't the first popular all-male singing group, but they were the progenitors of the '90s boy band.

Hanson

Taylor, Isaac, and Zac Hanson were three young brothers who played their own instruments and wrote their own songs. Even though they were probably just as annoying as any other boy band to people who didn't understand the phenomenon, there was some legitimacy to their stardom because of this.

Step by Step:
The NKOTB Guide to Creating a Boy Band

Three years after the New Kids broke up, pop radio stations suddenly became saturated with boy band music. The three biggest groups at the time were 'Nsync, Backstreet Boys, and 98 Degrees. Like the three Abrahamic religions, all of these groups had a common ancestor. It was obvious that they were borrowing from the New Kids model.

Step one:

The amount of love that girls have for a boy band is directly proportional to how stupid the band's name is. That is why the Backstreet Boys and 'Nsync (where the apostrophe before the "N" is actually a star), who both had very stupid names, were more popular in 1998 than 98 Degrees, who had a name that was more baffling than it was stupid.

Step two:

There should be five members in the group: no more, no less. The Backstreet Boys and 'Nsync both abided by this rule, while the less successful 98 Degrees had only four members.

Step three:

At least one member of the band has to be, not unattractive, but markedly less cute than the rest of the group. Or, barring this, one can just look fifteen years older than everyone else.

MAGIC EYE II

Now You See It...

3D Illusions by N.E. Thing Enterprises

MAGIC EYE

art of me thinks that the Magic Eye books deserve to be grouped with the likes of *Gravity's Rainbow*, *Moby Dick*, and other impenetrable classics. The first one in the series, *Magic Eye: A New Way of Looking at the World*, may have only been thirty-two pages long, but if you were unable to "diverge" your eyes in the way that the book's "viewing techniques" page described, it could have taken you longer to finish than it would have taken to read Tolstoy's *War and Peace* cover to cover. The sheer fact that these books had instructions was telling, and should have been enough to detract us from going any farther. But most of us flipped through it while we were at the bookstore or a friend's

The second book in the Magic Eye series, published in 1994, and a 2-D pattern hiding a 3-D image (it says "3-D").

house, staring at the abstract, computer-generated patterns, desperately trying to see . . . something.

Suddenly, though, you *did* see something. Your suddenly may have happened after an hour or a day, but it did happen.

Maybe you crossed your eyes by mistake or you held the book right up against your nose and slowly pulled it away from your face or the introduction's bizarrely philosophical "look through the page" directive finally made sense, and while studying a series of unremarkable red roses, a ghostly, 3-D heart emerged—an illusion made possible, as the book flap said, "by the remarkable power of modern computers." (Ah, those modern computers! What can't they do?) Sure, you'd seen hearts before and were actually quite adept at drawing them yourself, but this one was special; you'd earned the right to see it by making your eyes do something weird, and you'd never been so excited about anything so utterly meaningless.

ANOTHER DIMENSION

N. E. Thing Enterprises published the first Magic Eye book in 1993, although this sort of 3-D art had apparently been popular in Japan and Korea before the craze arrived stateside. I was about nine years old at the time, and I remember one day being in Crown Books with my mother and lying to her about my ability to see the images. There was an answer key at the back of the book that told you what you were supposed to be taking away from each page, and I'd quickly consulted that before showing my

First book in the Magic Eye series, published in 1993.

mother the book.
"It's some kanga-
roos boxing," I'd
said, while looking
at a multicolored

design that looked nothing like kangaroos boxing. My mother stared at the
page and said that she could see the kangaroos. Was she lying too? Was the
entire country lying? Were we all doing the Emperor's New Clothes thing
and pretending to see something that wasn't really there? It didn't matter.
Everyone was talking about this book, so my mother bought it and, later, the
next two in the series.

A NEW WAY OF LOOKING AT THE WORLD

Eventually there would be Garfield- and Looney Tunes–themed books,
but, in the beginning, Magic Eye was more of an adult phenomenon that kind
of trickled down to kids by virtue of being so ubiquitous—by 1994 there were
Magic Eye posters, T-shirts, greeting cards, and calendars. I didn't, however,
realize how serious N. E. Thing Enterprises was about their product. The view-
ing instructions in the front of the book make Magic Eye seem like the founda-
tion to some kind of New Age lifestyle. The author writes, "If possible, try to
learn to use your Magic Eye in a quiet, meditative time and place. It is difficult
for most people to first experience deep vision while otherwise preoccupied
in the distracting pinball of life." The tone is so serene, and referring to what's
going on in these books as "deep vision" makes it seem like staring cross-
eyed at a butterfly pattern could lead to enlightenment. Perhaps if we'd all
stared longer, and not just packed away the books after the fad died down, we
would've been elevated to a higher metaphysical plane where we'd be able to
astral project and finally understand the appeal of turquoise jewelry.

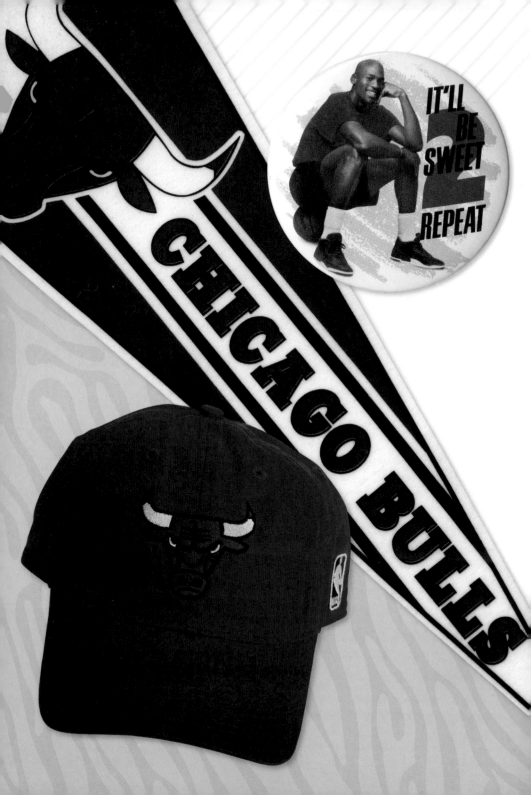

IT'LL BE SWEET 2 REPEAT

CHICAGO BULLS

THE CHICAGO BULLS

Michael Jordan is the closest that I can see us ever getting to a real-life superhero. He was beloved by everyone, the Nike Jumpman logo was revered just as much as the bat insignia or Superman's "S" shield, he could fly, and he fought crime. Well, maybe he didn't fight crime. But still, definitely cool and superhero-like.

A Michael Jordan pin and a Chicago Bulls pennant and hat. In the '90s the Bulls dominated on the court—and in merchandise sales.

DA BULLS

There are only ten NBA champion-
ship games in a decade and the Chicago
Bulls won six in the '90s. Michael Jordan
was a major part of that success, but
the Bulls were more than just a one-
man show. If Jordan was Batman, then
Scottie Pippen was Robin—he was
a scrappy, hardnosed player who
was good on defense and offense.
Dennis Rodman would have been
the Joker, then? I don't know; this
Batman analogy is wearing thin.
But Rodman, like Jordan, made
headlines. He joined the Bulls dur-

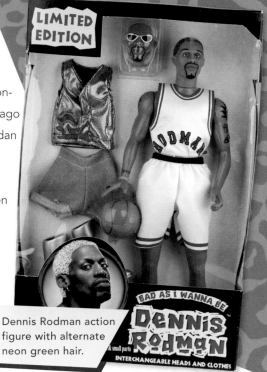

Dennis Rodman action
figure with alternate
neon green hair.

ing the 1995–1996 season and was one of the best rebounders in the game.
Most people knew him, though, for his antics—he once head-butted a referee;
he wore a wedding gown and married himself. Also his sometimes-green hair
and tattooed arms were shocking at the time. It's weird that Rodman's tattoos
were out of the ordinary back then—now, I think you're contractually obligated
to get at least fifteen tattoos when you sign with a team. Rodman was such a
dramatic figure that a Dennis Rodman "Bad as I Wanna Be" doll was released.
It had an interchangeable head—one head for on the court and one for being
as bad as he wanted to be.

HIS AIRNESS

On the court, Jordan elevated the level of play of everyone on his team,
so when the Looney Tunes gang needed to beat some mean aliens in a bas-
ketball game, who else would they ask to help them? *Space Jam* (1996) was a

live-action/animation hybrid that was like a throwback to *Who Framed Roger Rabbit*? It was one of the biggest kids' movies that year—resulting in all of the toys and action figures that you'd imagine. With all of the scandals and bad attitudes, no basketball player today could star in a movie that parents would be cool with letting their kids see.

Even if you weren't a Bulls fan, or even a basketball fan, you were probably a Michael Jordan fan. There are very few athletes in history who've had that kind of appeal. Jordan was the greatest not only because of the number of championships the Bulls won while he was playing, but also because of his image and charisma. He was like magic incarnate. Jordan was this inspirational figure, and anyone who's failed to make a team is told the same motivational anecdote to ease the blow: Michael Jordan didn't make his high school basketball team. But if that's true, what hope is there for the rest of us?

Elmer Fudd and Michael Jordan Tune Squad action figures from 1996.

145

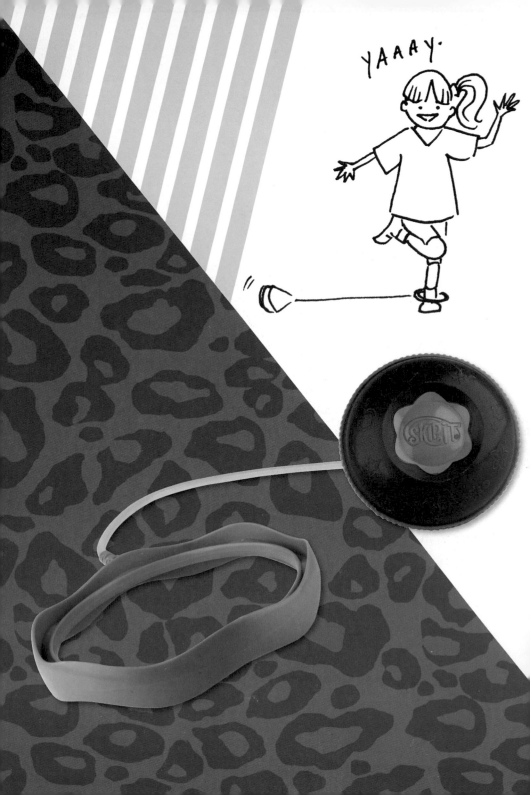

SKIP-IT

I can't wait to be an ornery ol' lady, wholly alienated by modern technology and shifting social mores, babysitting some cynical grandchild who, at seven years old, is totally dependent upon computers for entertainment (and possibly even has an ocular implant that allows her to turn on TV sets by blinking her eyes because it's the future!). Naturally, the kid will tell me that she's bored, and I'll finally get the opportunity to say, "When I was your age, we used to go outside and use one foot to twirl a cord connected to a clunky piece of plastic and then skip it with the other foot, and we loved every minute!" She'll follow this up with, "Grandma, what do you mean you used to skip it with the other foot? That doesn't make sense." To which I'll reply, "We just skipped it, OK? We skipped it!" And then I'll go eat a Fruit by the Foot, which hopefully will still exist fifty years from now.

 The Skip-It, invented by Victor Petrusek, was a modified ball and chain available in a variety of girl-friendly colors.

SEE WHAT JUST SKIPPED INTO TOWN

Tiger Electronics may have introduced Skip-It in the '80s, but the toy flourished in the '90s. I call it a "toy," but it was really more like a rudimentary workout apparatus for girls who were unwitting exercise buffs. If you were using a Skip-It, or as I like to say, Skip-Iting, then you were building your calf muscles, doing a little cardio, and, like Jennifer Grey at a country club in the Catskills, having the time of your life. A Skip-It was a ball with a small hoop tethered to it, which you'd slip your foot through and wear around your ankle. You would swing the Skip-It around in a circle and, with every revolution, hop over the tether with your other foot. It was kind of like hula hooping with your ankle instead of your waist. As a matter of fact, if you had a hula hoop, you could have just spun that around your ankle, but it would have been selfish of you to deny your parents the pleasure of buying you a new toy.

BUT THE VERY BEST THING OF ALL, THERE'S A COUNTER ON THIS BALL

The '90s model of the Skip-It had a mechanical counter (basically, an odometer) that kept track of how many rotations the ball made. The immediate goal was to top your previous score or, I guess, if you were playing with friends, to obliterate their scores and shame them. The ultimate goal, however (at least in my mind), was to beat the world record. Was there even a Skip-It world record? Probably not. But every time I slipped that plastic hoop over my ankle, my eyes were on the prize.

SKIPPIN' AND A-SCREAMIN' AND A-BOP-DO-BOP

There were a few hazards that came with all of this fun. If you weren't very coordinated or even just timed your skip wrong, you could wind up slamming that ball right into your ankle, and that wasn't the greatest feeling, both

because it hurt and because it was kind of demoralizing. The other, slightly more dangerous occurrence was that you'd try to go too fast and the Skip-It would fling off your ankle, wiping out any friends who might be standing nearby, almost certainly breaking anything breakable within the vicinity (including, sometimes, the Skip-It itself), but most important, wrecking your chance to obtain that Skip-It world record that the people over at Guinness surely must have been monitoring. The benefits far outweighed the dangers, though. Skip-It encouraged kids to go outside and be active, and that doesn't seem to be a huge priority with toymakers today.

Bop It!

In 1996, if you didn't want to Skip-It or Squeezit, you could Bop It. The original version of the electronic Hasbro game was shaped like a baton with a circular button built into the center and a handle on either side—one that could be twisted and one that could be pulled. Three commands—"Bop it," "Twist it," "Pull it"—were randomly called out from a built-in speaker and the objective was to follow the tyrannical orders of the Bop It in time with the music. As the game progressed, the music would speed up, making it difficult to obey Lord Bop It. If you were too slow or, I don't know, pulled it when you should have twisted it, then Bop It screamed in agony. You had let yourself down. You had let Bop It down. You were a disgrace to your family.

Bop It could be played solo or with a group. The multiplayer mode, called Vox Bop, included the "pass it" command. The game was loud and irritating to most adult ears, but once during seventh-period physics, we somehow managed to pass a mini-key-chain Bop It around the class without the teacher noticing and consequently proved Newton's first law of motion: an object in motion (Bop It) will stay in motion unless an unbalanced force (teacher) acts upon it. At the end of the school year, I received the physics award. Thank you, Bop It.

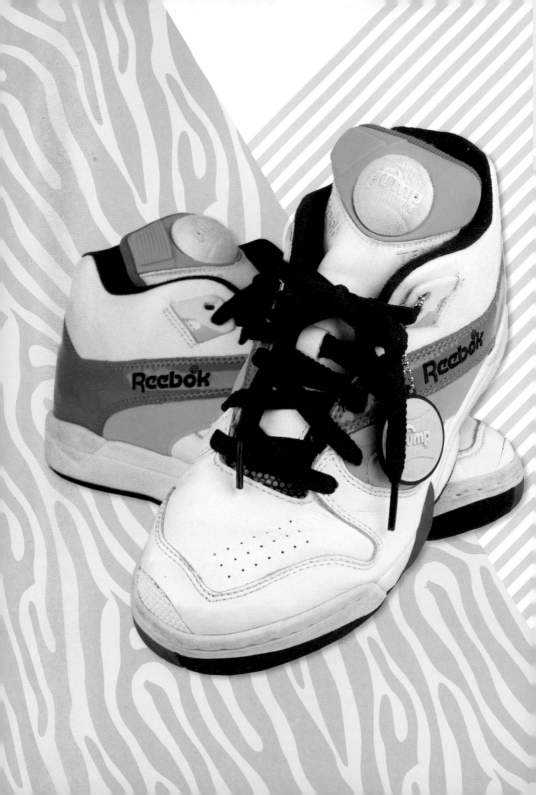

HIGH-TECH FOOTWEAR

Children of the '90s weren't content to just have shoes that protected our feet from the elements. We wanted shoes that did other things, even if those things had no practical use. L.A. Lights and Reebok Pumps were the final word in foot fashion. Long gone were the Velcro-laden dark ages of shoes. It was the '90s, and we had shoes to reflect our modern tech-savvy lifestyles.

After the success of the original Reebok Pump basketball high-tops, the company targeted other sports. The pumps on these sneakers resemble tennis balls.

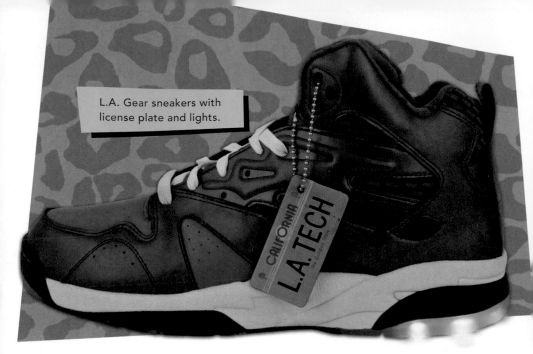

L.A. Gear sneakers with license plate and lights.

L.A. LIGHTS

Even without the lights, L.A. Gears were cool. They had "L.A." on them and that was a cool place. Sure, the soles of every pair of L.A. Gears I ever owned started to peel off, but they came with that tiny "L.A. Gear" license plate key chain, and that more than made up for it.

L.A. Gear launched the L.A. Lights kids footwear line in 1992. It was like the people over at L.A. Gear just intuitively knew what every kid wanted: shoes that lit up! They could be sneakers or sandals and came in both girl and boy models. The design deserved the Nobel Prize in Shoe Technology. And if no such prize exists,

BLINK!

one should certainly be created and then given to the genius cordwainer who came up with L.A. Lights. You'd walk around with your heels flickering, feeling awesome and knowing that you were the envy of every kid that you passed.

REEBOK PUMPS

Released in 1989, the original model had a small orange basketball on the tongue of the sneaker—the inflation system—which you'd press. Each time you pressed it, or *pumped* it, the shoe became tighter, providing you with a "custom fit" and ankle support—although no one was asking their parents for these because they had legitimate concerns about athletic injuries. It was fun to pump them up as tight as you could and then release the air—at least that was the kid perspective.

The sneakers also came in men's and women's sizes. Adults like the brand's first spokesperson, NBA star Dominique Wilkins, seemed to take their pumps more seriously, making sure to give them a squeeze before beginning any athletic activity and refusing to acknowledge that they were wearing toys on their feet.

Reebok pumps: keeping it tight since 1989.

1992 BARCELONA SUMMER OLYMPICS & THE DREAM TEAM

America is great. I like all the freedom that we've got going on here and the wide array of fast-food options. But I don't generally walk around thinking about my Americanness. It usually only crosses my mind when I'm reciting the Pledge of Allegiance (and I haven't been required to do that since high school, so it almost doesn't count), when Old Navy starts selling those American flag T-shirts toward the end of June every year, when I receive a jury duty summons, and during the Olympics. The Olympics is the big one, though, because I'm not just

Cobi, the official 1992 Summer Olympics mascot, and a pennant celebrating America's men's basketball team—the players all apparently had really white teeth.

 reminded of the fact that I'm American—suddenly, I'm overcome with extreme Continental Congress–level patriotism. This was especially true when I was in elementary school. I'd keep a close eye on the number of medals that the United States won and every time the number increased, I felt like I'd accomplished something, even though I was just watching TV and eating Cheetos. The first year that I was old enough to appreciate what was happening in the Olympics was 1992, and it was probably the best time to be introduced to the tradition. Not only was it the last time that the Winter and Summer Games took place in the same year, but it was the year that the Dream Team debuted.

THE DREAM TEAM

The 1992 Summer Olympics were held in Barcelona, Spain. The official mascot was Cobi, the vaguely cubist Catalan sheepdog. The Games that year were noteworthy for a couple of reasons that had nothing to do with American athletes (because apparently important things happen in other countries sometimes). The dissolution of the Soviet Union in 1991 meant that there were several newly independent nations competing, and South Africa, which was in the process of dismantling the apartheid system, was allowed to participate for the first time since the '60s. I didn't care or realize that any of these things were happening. I wasn't a xenophobe. I was nine years old.

Regardless of your age, it would have been impossible not to know about the Dream Team. Because of a change in the rules, professional basketball players would be allowed to compete in Barcelona. Before 1992, the American Men's basketball team had been made up of the country's college all-stars. It may have been because these kids weren't used to playing with one another, but for whatever reason, the U.S. wasn't dominating the sport. And that annoyed us.

The NBA players assembled for the Olympic team weren't just the best in the league at that time; they were some of the best in the sport's history: Magic Johnson, Larry Bird, Charles Barkley, Patrick Ewing, John Stockton, David Robinson, Karl Malone, Scottie Pippen, Clyde Drexler, Michael Jordan (duh), and Chris Mullin (whose inclusion was a point of pride for me because he played for my hometown Golden State Warriors and through the transitive property I was actually in the Olympics that year). One college player, Christian Laettner, was also added to the roster. They were dubbed the Dream Team but could have also been called the Mean Team. Not that they weren't nice fellows, but, c'mon, Michael Jordan? That's not just unfair; it's dirty.

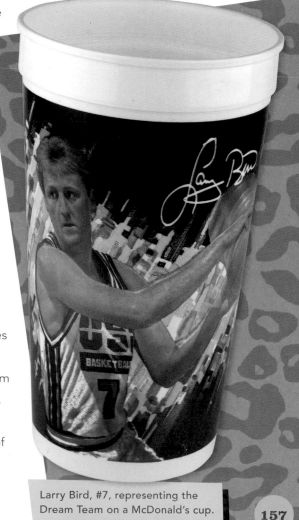

To celebrate how badly we were going to beat the other countries with this ridiculous lineup, commemorative figures and plates, T-shirts, replica jerseys, trading cards, and puzzles were being sold. The players' faces were put on everything from Corn Flakes to McDonald's cups. I don't think anyone would have been surprised to see a picture of the team on a Tampax box.

Larry Bird, #7, representing the Dream Team on a McDonald's cup.

America loves a good underdog story, but we'll take an over-dog story, too, if it means that we're the victors. Naturally, the Dream Team brought home the gold medal, winning all of their games by an average of almost fifty points. There wasn't a single player on any of the other teams whose skill level was comparable to anyone playing for America. These guys were superstars: everyone realized this, and players from the other nations were asking for their autographs.

Right now there are more international players in the NBA than ever, and the Dream Team, who were like ambassadors for the league, are often credited with laying the foundation for this transformation. In the immediate aftermath of the Games, Toni Kukoc, a member of the silver medal–winning Croatian team, became an active member of the Chicago Bulls. But with people from all over the world paying such close attention to these American basketball icons, you have to imagine that a future NBA player like Dirk Nowitzki (arguably the best international player of all time), who grew up in Germany and was about fourteen in 1992, would have studied the Dream Team's every move.

DREAM ON

One reason why the Olympics are so interesting when you're young is because you have yet to realize your limitations. You watch the Games and think, "Yup, I'm probably going to win a gold medal one day." Well, chances are you never did. Sorry, man.

The Olympics in the '90s

1994 Winter Olympics – Lillehammer, Norway

Seven weeks before the Olympics, American figure skater Nancy Kerrigan was clubbed in the knee during an attack orchestrated by the ex-husband of Tanya Harding (a competitor of hers). Oksana Baiul, a sixteen-year-old orphan and scrunchie devotee from Ukraine, won the gold in the event. Kerrigan, who'd managed to make a come-back after the attack, won the silver medal but was really snotty about it, com-menting on how emotional Baiul was after her win. But orphans are totally overrated, so who wouldn't have acted like a jerk in that situation?

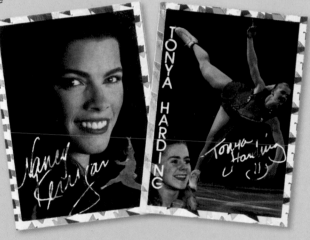

1996 Summer Olympics – Atlanta, Georgia, United States

The American women's gymnastics team, which became known as the Magnificent Seven, clinched the gold after a vault executed by an injured Kerri Strug. Strug became such a beloved figure after this that she made an appearance on *Beverly Hills, 90210*.

1998 Winter Olympics – Nagano, Japan

Snowboarding debuted, giving the ancient Games some credibility with the world's cool kids, but this was imme-diately undermined by the fact that curling, a "sport" in which "athletes" sweep ice (as far as I can tell), also debuted that year. During the always-exciting figure skating competition, fifteen-year-old American Tara Lipinski became the youngest ath-lete to win a gold medal in the Winter Games.

159

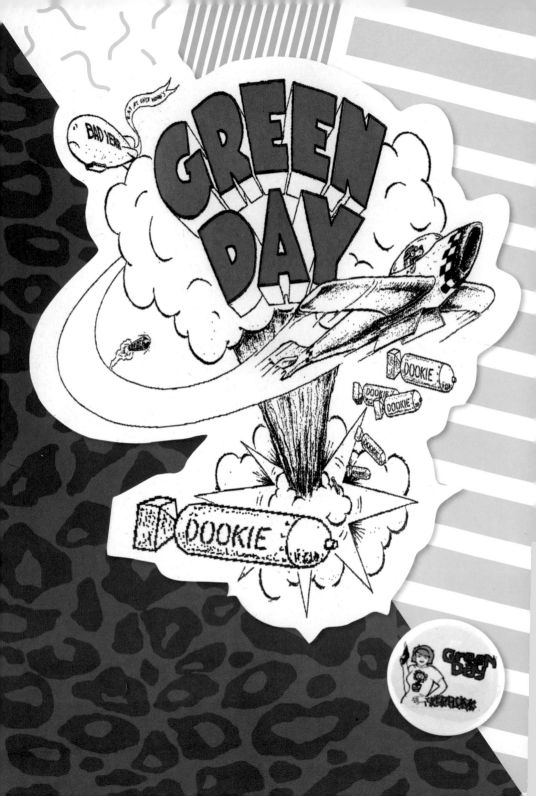

GREEN DAY

Green Day's "Longview" was one of the first songs that I learned to play on the guitar. My hippie guitar teacher would sort of sing some of the words as we strummed along to the CD together. This made me really uncomfortable, not only because it's just inherently weird to listen to a hippie sing, but because the song is about masturbation.

The story of Green Day's rise—and the resulting rise in hair dye sales—is one of the decade's most fascinating. They went from punk kids playing underground clubs to penning "Good Riddance (Time of Your

A sticker featuring the cover art from *Dookie*, Green Day's major label debut, and a button featuring the cover art from their final release on the independent label Lookout!, *Kerplunk*.

Life)," the most ubiquitous song of 1998—it was probably a favorite of your great-aunt or grandma—without making any fundamental changes to their band.

Billie Joe Armstrong, Mike Dirnt, and Tré Cool started out performing at notorious punk club 924 Gilman Street in Berkeley, California, but were spurned from their old stomping ground when they signed to a major record label: Gilman Street doesn't tolerate sellouts. Their first mainstream album, *Dookie*, was released in 1994, went to number two on the charts, and won a Grammy Award for Best Alternative Music Album (a category that had existed only since 1991).

PUNK'S NOT DEAD

At the beginning of the decade, grunge bands like Pearl Jam, Soundgarden, and naturally, Nirvana, dethroned the '80s hair bands that had dominated rock. Their success legitimized alternative music from a commercial standpoint and their angsty, sincere music resonated with rock fans. Though the styles were different, they shared the DIY spirit of punk, and the good will they garnered paved the way for Green Day. After *Dookie* and their follow-up, *Insomniac*, there were kids with green hair everywhere—not unlike drummer Tré Cool. The hardcore punk crowd's loss was suburbia's gain.

At this point, Green Day was popular only amongst a certain group of people. At my middle school, we called them "rockers"— maybe they were called "alternative" kids at yours—but they wore chain wallets and Airwalks, and when my friends and I were scribbling "wassup?" on our JanSport backpacks in whiteout pen, they were writing "Green Day." Kids were seeking out semipermanent ways to demonstrate how they felt about this

The rocker kid's chain wallet looks best paired with green hair.

band—the hair, the whiteout pen, stickers, patches—and when you're in middle school, that's the equivalent of a tattoo.

EVERYBODY ELSE IS DOING IT

After "Good Riddance (Time of Your Life)" came out, this band that had been a subculture favorite was articulating everyone's experience. The song was used during graduation ceremonies and was even in a *Seinfeld* retrospective after the show ended. The mainstreaming of Green Day peaked in 2009 with the creation of *American Idiot*, a stage musical adapted from their album of the same name. If you go to the show, you will find it very entertaining and you will be sitting next to a senior citizen. I speak from personal experience.

Pop Rock in the '90s

Presidents of the United States of America
Probably known best for their quirky song "Peaches," which doesn't seem to be a metaphor for anything and is literally just about peaches, the Presidents of the United States of America were nominated for a Grammy, and "Weird Al" Yankovic parodied their already-humorous single "Lump," turning it into a song called "Gump," all in 1996.

No Doubt
We all knew way too much about their personal business, thanks to "Don't Speak," a chart-topper from their 1995 album *Tragic Kingdom* that was about the end of the relationship between lead singer Gwen Stefani and bassist Tony Kanal. The band's ska punk sound helped popularize the genre during the '90s, but unlike, say, the Mighty Mighty Bosstones, No Doubt reinvented themselves and continued to flourish at the beginning of the 21st century.

Red Hot Chili Peppers
All of the Red Hot Chili Peppers songs sound the same. But in the '90s we didn't know that yet because we hadn't heard them all. While everyone's familiar with 1992's "Under the Bridge," their best to date may be "Soul to Squeeze," a 1993 single that was available only on the *Coneheads* soundtrack during the '90s.

PERFECT *Strangers*

LAFFS

Larry Appleton

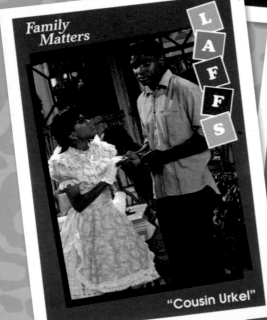

Family Matters

LAFFS

"Cousin Urkel"

FULL HOUSE

LAFFS

"Shape Up"

TGIF

f it was Friday night and the mood was right, you'd tune into TGIF (or Thank Goodness It's Funny), ABC's end-of-the-week, family-friendly two-hour programming block. Although TGIF started in 1988, the concept blew up in the '90s. *Full House*, *Family Matters*, *Dinosaurs*, and *Perfect Strangers* were all a part of the 1991 lineup, each sitcom

★ LAFFS TV trading cards were released in 1991. There were eighty "side-splitting" cards in total, each featuring production stills from TGIF sitcoms.

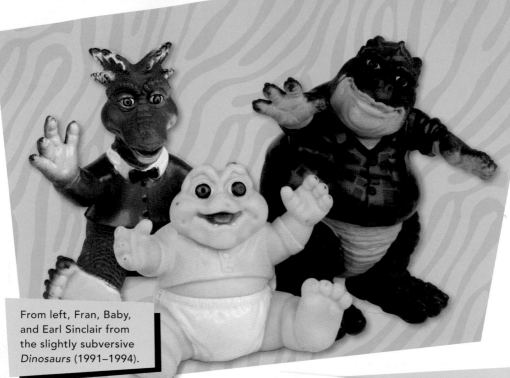

From left, Fran, Baby, and Earl Sinclair from the slightly subversive *Dinosaurs* (1991–1994).

presenting a twist on the conventional TV family. Not a huge twist—there wasn't anything subversive—but a quaint twist. In *Full House*, three clueless men were raising three girls and the twist was that two of the men had mullets. The Winslows of *Family Matters* were African American instead of white (so, you know, *kind* of a twist?). In *Perfect Strangers*, Larry and Balki, distant cousins, were living together in an "odd couple" situation precipitated by Balki's wacky foreign-ness and

Larry Appleton and Balki Bartokomous in *Perfect Strangers* (1986–1993).

Larry's rigid American-ness. And the Sinclairs on *Dinosaurs* were a dinosaur family, which was totally normal, but each belonged to a different genus (the dad was a Megalosaurus, the mom was an Allosaurus). Now that I think about it, *Dinosaurs* may have actually been a little subversive.

Full House, *Family Matters*, *Perfect Strangers*, and a later entry, *Step by Step*, were all produced by Miller-Boyett. There were certain features that ran through most of the company's shows that would come to define what TGIF was at the start of the decade. To begin with, each series

FULL HOUSE

L
A
F
F
S

"One Last Kiss"

Jesse Katsopolis and Joey Gladstone rocking it out on *Full House* (1987–1995).

had a theme song that was bafflingly grandiose with poetic lyrics that were sometimes nonsensical and usually at odds with the show's content. *Perfect Strangers'* theme included the line "standing tall on the wings of my dreams," but I can't recall a single episode where that ever happened. There was a laugh track, though, and a lot of slapstick, so maybe the lyric was a metaphor for that. "All I see is a tower of dreams, real love burstin' out of every seam" was a verse from the *Family Matters* theme. Even though the song was kind of my jam, I'm not completely sure that towers have seams, so it was a bit confusing.

The "dumb interloper" was also a TGIF mainstay. This was a character with a relatively low IQ who was by all appearances neglected by his or

her own parents and latched onto the family at the center of the show in an attempt to soak in some of that loving domesticity. That was all subtext, of course, because these characters were used for comic relief. We were supposed to laugh when notoriously smelly-footed Kimmy Gibbler rolled into the Tanner home on *Full House*, when airhead Cody made an appearance on *Step by Step*, or when the Winslows met the improbably named dimwit Waldo Geraldo Faldo. But they were all tragic figures.

RATING TGIF CATCHPHRASES

I think during the early days of TGIF, shows didn't get a green light from the network unless the writers had at least one solid catchphrase. If you wanted to make *Perfect Strangers*, it wasn't going to matter how sexy Mark Linn-Baker was. No catchphrase, no go. This is because ABC understood how satisfying it is to hear our favorite characters say the same thing over and over again, week after week.

have MERCY!

But which show had the best signature quips? Since everyone secretly or not-so-secretly wants his or her whole identity boiled down to some snappy or cute one-liner, the only way to rate each catchphrase is on a scale from 1 to 5 based on how easy it would be to smoothly incorporate the lines into our daily lives. After using a catchphrase that rates a 1 on the scale, you would be met with perplexed stares or possibly shunning, and one that rates a 5 would have everyone in your social circle thinking that you were the adorable scamp of their family-friendly dreams.

Perfect Strangers	Family Matters	Dinosaurs	Full House
"Now we are so happy we do the dance of joy!" (Balki Bartokomous) **-2**	"I've fallen and I can't get up!" (Steve Urkel) **-2**	"Not the mama!" (Baby Sinclair) **-1**	"You got it, dude." (Michelle Tanner) **-4**
"Don't be ridiculous." (Balki Bartokomous) **-4**	"Whoa, mama." (Steve Urkel) **-3**	"I'm the baby, gotta love me!" (Baby Sinclair) **-2**	"How rude!" (Stephanie Tanner) **-3**
	"Did I do that?" (Steve Urkel) **-5**		"Have mercy!" (Uncle Jesse) **-3**
			"Cut-it-out!" (Joey Gladstone) **-2**
			"This is nuts." (Michelle Tanner) **-3**
			"Will there be . . . wood?" (Joey Gladstone via Mr. Woodchuck doll) **-2**
			"You're in big trouble, mister." (Michelle Tanner) **-3**
TOTAL: **6**	TOTAL: **10**	TOTAL: **3**	TOTAL: **20**

STEVE URKEL

His voice was high in pitch and nasally in timbre. He had an inexplicable devotion to cheese and an inability to take a hint or accept straightforward declarations of contempt and revulsion. On top of all of that, there was his general maladroitness and nerdiness. This was Steve Urkel, the Winslows' annoying neighbor and the only reason anyone remembers *Family Matters*. It would seem to defy reason, but he was popular enough to justify guest appearances on two other TGIF shows (*Full House* and *Step by Step*) and the creation of a doll. As the commercial explained, the Talking Urkel doll had Steve's looks, his laugh, his voice, and all. I don't even want to know what the "and all" was. If the idea of an Urkel doll wasn't already terrifying enough, in *Family Matters*' eighth season, a maniacal Steve Urkel ventriloquist dummy

named "Stevil" comes to life. The number of Talking Urkel dolls thrown away after that episode aired must have been staggering.

Despite his unpleasant traits, when you consider how well the character was received by viewers and, within the context of the show, his eventual absorption into the Winslow family, who'd had so much contempt for him at the start of the series, it's hard not to see Urkel as a symbol of perseverance. He taught us that if you're obnoxiously persistent, hike your pants up just the right amount, and lead with your pelvis in every situation, you'll be a sensation.

A showdown between Carl Winslow and Steve Urkel in *Family Matters* (1989–1998).

"The Good, The Bad & The Urkel"

The Steve Urkel talking doll: rolled-up pants, suspenders, glasses . . . If he only knew what a hipster he would become.

GONNA HAVE SOME FUN, SHOW YOU HOW IT'S DONE

TGIF made sitting in front of the TV seem like an event. When these shows were airing, it was exciting to spend your whole Friday night at home. These days, not so much.

Boy Meets World

Joining the TGIF lineup in 1993, *Boy Meets World* starred Ben Savage as Cory Matthews, a typical kid, dealing with the ups and downs of adolescence and eventually young adulthood. The show is noteworthy for having not one, not two, but three *Tiger Beat* centerfolds in its cast (Rider Strong, Will Friedle, and Matthew Lawrence).

The irony of *Boy Meets World* was that Cory never "met the world" and led a surrealistically localized life. He resided in the Philadelphia metropolitan area from the start of the show to its finale in 2000; he married Topanga, the girl who sat in front of him in middle school; and Mr. Feeny, his neighbor/mentor, was his sixth grade teacher, his high school principal, and later, one of his college professors.

A STEVEN SPIELBERG FILM

JURASSIC PARK ™

An Adventure
65 Million Years In The Making.

UNIVERSAL PICTURES PRESENTS AN AMBLIN ENTERTAINMENT PRODUCTION SAM NEILL LAURA DERN JEFF GOLDBLUM
WITH RICHARD ATTENBOROUGH JURASSIC PARK BOB PECK MARTIN FERRERO B.D. WONG SAMUEL L. JACKSON WAYNE KNIGHT
JOSEPH MAZZELLO ARIANA RICHARDS CASTING BY JANET HIRSHENSON DINOSAURS STAN WINSTON FULL MOTION DENNIS MUREN VISUAL EFFECTS SUPERVISOR PHIL TIPPETT
SPECIAL DINOSAUR EFFECTS MICHAEL LANTIERI MUSIC JOHN WILLIAMS EDITED BY MICHAEL KAHN PRODUCTION DESIGNER RICK CARTER DIRECTOR OF DEAN CUNDEY A.S.C
BASED ON THE NOVEL BY MICHAEL CRICHTON SCREENPLAY MICHAEL CRICHTON AND DAVID KOEPP PRODUCED BY KATHLEEN KENNEDY AND GERALD R. MOLEN
DIRECTED BY STEVEN SPIELBERG SPECIAL VISUAL EFFECTS BY INDUSTRIAL LIGHT & MAGIC A UNIVERSAL PICTURE

PG-13 PARENTS STRONGLY CAUTIONED

STEREO

MCA
UNIVERSAL
HOME VIDEO

JURASSIC PARK ™

VHS ®
HI FI

DOLBY SURROUND
STEREO

81409

JURASSIC PARK

Exceptionally wealthy and idealistic Dr. Hammond (played by the sexier Attenborough brother, Richard) creates a dinosaur theme park with actual dinosaurs by extracting their DNA from mosquitoes trapped in prehistoric amber. To appease investors who've become concerned after a worker's recent death-by-dino, he agrees to bring scientists to the park, have them look it over, and see if they'll give it an endorsement. Paleontologist Dr. Alan Grant (Sam Neill); Grant's leggy, paleobotanist partner, Dr. Ellie Sattler (Laura Dern); and chaos theorist

 Jurassic Park was released on VHS in 1994 and not 65 million years after its big-screen premiere. In case you were confused by the movie's clever tagline.

Dr. Ian Malcolm (Jeff Goldblum) all arrive at the park, along with Hammond's two grandchildren, Lex and Tim. The dinosaurs are chill at first, but then they're not so chill.

WELCOME TO JURASSIC PARK

Directed by Steven Spielberg and based on a dense novel by Michael Crichton (which I attempted to read when I was in the fifth grade but couldn't finish because it was roughly five million pages long), *Jurassic Park* forever altered how we view action movies and what we expect from them technically. The visual effects were revolutionary—the dinosaurs were created using both animatronics and new digital effects. The texture of the dinosaurs' skin, the way they moved: it all seemed so realistic. According to Tom Shone's book *Blockbuster: How Hollywood Learned to Stop Worrying and Love the Summer Movie*, George Lucas was present at a test screening of the CGI dinosaurs during production, and the *Star Wars* director started to cry.

The action was relentless. Every moment of relief was immediately followed by total terror. In one scene Tim and Lex run into a kitchen, seemingly safe behind a closed door, but—oh wait—dinosaurs know how to open doors now. You left the theater feeling like you'd really experienced something, like you'd gone through some stuff and come out the other side a different person. *Jurassic Park* grossed $914,691,118 worldwide, which doesn't even seem like a real number. Two sequels, a comic book series, a junior novelization (that was a vast improvement on Crichton's book), and video games followed. Tonya Harding even skated to music from *Jurassic Park* during the 1994 Winter Olympics, so this movie was everywhere.

Dr. Ellie Sattler action figure.

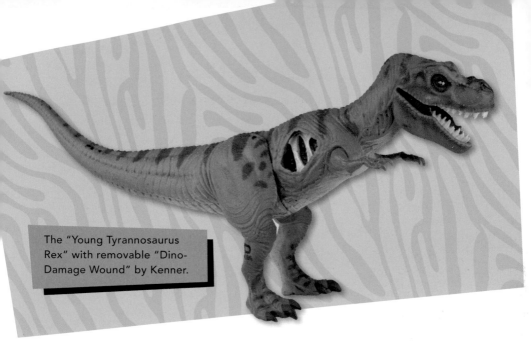

The "Young Tyrannosaurus Rex" with removable "Dino-Damage Wound" by Kenner.

DINO-DAMAGE

Immediately after watching *Jurassic Park*, you wanted to watch it again. If you had parents who for some reason didn't want to spend the rest of their days taking you to see the movie, at least there was Kenner's 1993 *Jurassic Park* toy line, which allowed you to transport a tiny bit of that dino horror into your house. The first series featured five human characters (Alan Grant, Ellie Sattler, Tim, Robert Muldoon, and Dennis Nedry) and eleven different dinosaur figures. They were all packaged with a collectible card, but the human characters also came with a baby, pet-sized dinosaur and a weapon, presumably to kill the baby dinosaur Old Yeller–style.

After a movie like *Jurassic Park*, you weren't going to be satisfied with just banging two dinosaur toys together while saying "grrr" or "arrr" (or whatever your dinosaur play sound might be). Kenner intuited this and made toys with moving and breakaway parts. The "Young Tyrannosaurus Rex," for example, had a removable "Dino-Damage Wound"—a small

circular chunk of its torso could be removed to expose its rib cage. The Dimetrodon had "Dino-Strike Clamping Jaws"—its mouth clamped when you pulled one of its hind legs.

The following year, a new series was released, expanding the JP universe with new human characters called "Dino Trackers" that weren't in the movie. Harpoon Harrison wore green cargo shorts and a vest Rico Suave–style (i.e., with no shirt). Possible explanations for the design: harpoon was either trying to intimidate the dinos he was tracking with his rock-hard abs or hoping to distract a dino by lulling it into a false sense of eroticism.

JURASSIC PARK'S LEGACY

Kids already tend to look at the world with wide-eyed amazement, but this movie was huge, and for some of us it was our first experience with the modern big-budget, audio-reverberating-in-your chest action movie. Several of my classmates at the time were so moved by what they'd seen that they wanted to be paleontologists.

Sergeant "T-Rex" Turner.

Barney the Big Purple Dinosaur

Barney was a purple and green plush dinosaur, often seen sitting eerily on a tire swing or a tree stump without anyone having put him there. He'd be brought to life, that is, turned into a giant, giggling dinosaur, through the imagination of a group of children. That's right—all of the singing, dancing, and learning on *Barney & Friends* was actually a shared hallucination.

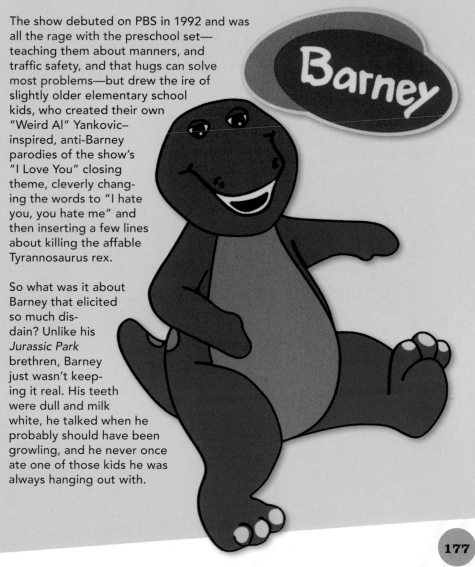

The show debuted on PBS in 1992 and was all the rage with the preschool set—teaching them about manners, and traffic safety, and that hugs can solve most problems—but drew the ire of slightly older elementary school kids, who created their own "Weird Al" Yankovic–inspired, anti-Barney parodies of the show's "I Love You" closing theme, cleverly changing the words to "I hate you, you hate me" and then inserting a few lines about killing the affable Tyrannosaurus rex.

So what was it about Barney that elicited so much disdain? Unlike his *Jurassic Park* brethren, Barney just wasn't keeping it real. His teeth were dull and milk white, he talked when he probably should have been growling, and he never once ate one of those kids he was always hanging out with.

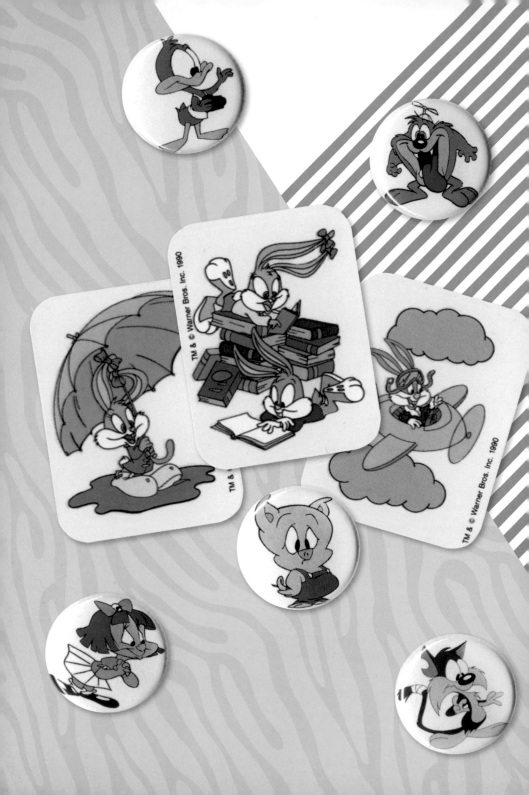

TINY TOON ADVENTURES

You'd see slapstick and anvils aplenty, but *Tiny Toon Adventures* was often satirical and frequently featured clever pop culture parodies (many, like their *Citizen Kane* and *Deliverance* spoofs, were so far beyond our comprehension level), and that was what set it apart from its contemporaries. OK, so no kid watching the first episode of the show, where the writers poke fun at the idea of creating a cartoon about anthropomorphized bunnies, was thinking, "Hmm, I quite enjoy how self-referential *Tiny Toons* is," but it was self-referential, it was irreverent, and we were laughing.

Tiny Toons Adventures pins and Babs and Buster Bunny stickers that could have been used to decorate school folders, clothes, younger siblings, or a parent's car windows.

WE'RE TINY, WE'RE TOONY

Everyone knows that the best way to invigorate an old TV show or bring a floundering franchise to a new audience is to turn its iconic characters into children. It worked in the '80s with *Muppet Babies*, and in 1990, it worked with *Tiny Toon Adventures*. Produced by Steven Spielberg, the show was a *Looney Tunes* spin-off of sorts where the fourteen-year-old, anthropomorphized, wacky animals attending ACME Looniversity were students of Bugs, Daffy, Porky Pig, and the rest of the classic crew. Each of the new characters was modeled after the older generation: wise-cracking duo Buster Bunny and Babs Bunny (no relation) were Bugs stand-ins, green duck Plucky had the same grandiose delusions as Daffy, and Hampton J. Pig was as timid as Porky, and when describing himself said, "I react to characters funnier than I am and I have low self-esteem."

Tiny Toons merchandise was abundant during this time and all of the main characters became stuffed toys. The weird thing about these stuffed animals was that their clothes were removable—there was no tag on the toy advocating the removal of their clothes, but it could be done. Why would anyone do this? Just because. All of the characters looked weird in the buff, but naked Hampton was scandalous. Being a pig, Hampton was a pink color that could feasibly be the color of a person's skin, so without his overalls, he looked remarkably naked. Like, too naked. The strip-down would have been an embarrassing experience for both Hampton and the person disrobing him.

Hampton J. Pig in his curiously removable overalls.

WE'RE ALL A LITTLE LOONEY

Although it borrowed elements from the past, this wasn't your standard weekday afternoon cartoon. The budget was bigger (something that was bound to happen with Spielberg attached), a thirty-piece orchestra provided the score for each episode, and there was a lot of wit guiding the show's silliness. In the first episode there were throwaway, random references to Ted Turner, Roger Rabbit, *The Wizard of Oz*, *Hamlet*, and *The Shining*.

If you're reading this, odds are, you're the kind of person who obsesses over pop culture. You may even speak to your friends entirely in movie quotes. *Tiny Toons* and all of its allusions were probably a precursor to that, leading you to believe it was normal behavior.

More Steven Spielberg Cartoons

Animaniacs
Animaniacs, broadcast 1993–1998, was full of vaudevillian visual gags and "Who's on first?" banter. The bulk of the show was about zany Yakko, Wakko, and Dot Warner (the Warner brothers and the Warner sister). They were dogs, maybe (it was never made clear what species they were). Other short segments followed characters like Chicken Boo—a giant chicken that was always mistaken for a human—and the Goodfeathers—a *Goodfellas* parody where wise-guy pigeons perched on a park statue of Martin Scorsese. In one seminal *Animaniacs* episode, Yakko recited the names of every nation on a map in a song called "Yakko's World."

Pinky and the Brain
Pinky and the Brain were two white lab rats—Pinky was the tall, dimwitted British one and Brain was the short, genius, Orson Wellesian one, hell-bent on world domination. The characters were initially featured during *Animaniacs* but proved so popular that they spun off into their own show that aired 1995–1998. In every episode, Pinky asked, "Gee, Brain. What are we gonna do tonight?" To which Brain responded, "The same thing we do every night, Pinky. Try to take over the world."

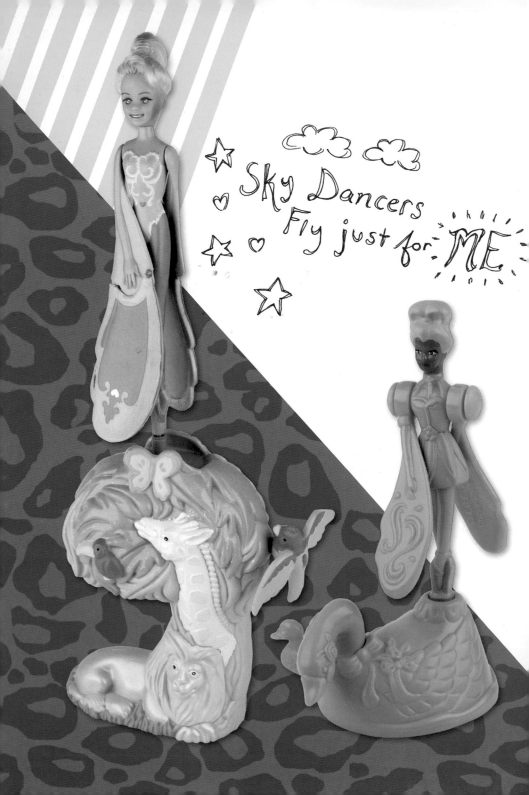

Sky Dancers
Fly just for ME

SKY DANCERS

The Sky Dancers theme was the single most nightmarish commercial jingle of the '90s, maybe even in all of history. But you may not have noticed because the delicate melody and the young singer's sweet, lilting voice disguised how eerie the lyrics were. Without the tune to distract us, we can examine the words more carefully. "Fly for me! Just for me! Sky Dancers, fly for me!" the singer commands. "Come to me! Dance for me! Sky Dancers, fly for me!" I don't know about you, but when I think about those words, this macabre scene pops into my head.

 A deceptively nonthreatening Sky Dancer doll on a jungle-themed pull-string launcher and a McDonald's Sky Dancer Happy Meal toy from 1996.

I see a wild-eyed girl with steepled fingers, sitting on a throne. There's a small goblin perched on her shoulder, and she's smirking devilishly as she orders these poor imprisoned Sky Dancers to amuse her. "Fly for me," she cackles. "Just for me!" If we had all paid closer attention to how truly sinister this song was, perhaps it wouldn't have been so surprising when the Sky Dancers revolted and started smacking little girls in the face with their stiff foam wings.

WOW, THEY REALLY FLY!

Introduced in 1994, Sky Dancers were described as "real flying dancers with magical wings and pretty dresses." These willowy ballerina dolls with tulle skirts and hair pulled into elegant updos came in the classic pastel pinks, purples, and blues that are supposed to entice girls and repel boys. However, they weren't your typical dolls, and I don't think that it was uncommon for boys to have wanted to play with them. Why, you ask? The original Sky Dancers were propeller launchers! That's right, propeller launchers. For girls! It was a beautiful thing. You mounted your Sky Dancers on molded plastic platforms designed to look like clouds, dolphins, horses, or "magic stars," pulled a string, and the dolls shot up into the air, spinning their wings like fancy helicopter ladies. Sometimes I feel like there's this perception in the toy-manufacturing industry that girls don't like to play with mechanized toys unless they're baby dolls that talk, chew food, or urinate, but Sky Dancers proved that girls

Sky Dancer Happy Meal toy: it's so much fun even a boy would be tempted to play with it.

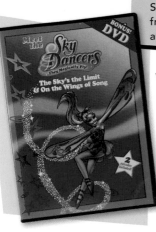

want to launch crap into the air just as much as boys do—and that boys might be down to play with a pink doll if it was awesome, which Sky Dancers were.

The Pretty Lights Sky Dancers, which had light-up chests and feet and shimmering jewels on their launchers, came out in 1995. The McDonald's Happy Meal toys soon followed. This version was much smaller, of course, and didn't fly, but it could twirl (and for a Happy Meal toy, that's an exciting feature). Finally, Sky Dancers became so popular that an animated series based on the toys was created. The show chronicled the aerial adventures of five exceptional dance students who become winged defenders of the Sky Realm.

But these aren't the reasons why Sky Dancers are remembered.

TOTAL RECALL

According to the U.S. Consumer Product Safety Commission, Galoob, the company that manufactured Sky Dancers in the mid-'90s, received more than one hundred reports of the dolls injuring kids. But these rogue Sky Dancers weren't just hitting kids; they were kicking their asses. Broken ribs, scratched corneas, mild concussions, and temporary blindness were among the injuries reported. In 2000, all Sky Dancers manufactured before that year were understandably recalled and are now considered by many to be one of the most dangerous toys of all time. I feel horrible for anyone who was hurt by this toy, especially the people with the broken ribs (I can't even imagine how that happened), but I have to admit that I think it's cool that a doll, intended for girls, was raising so much hell.

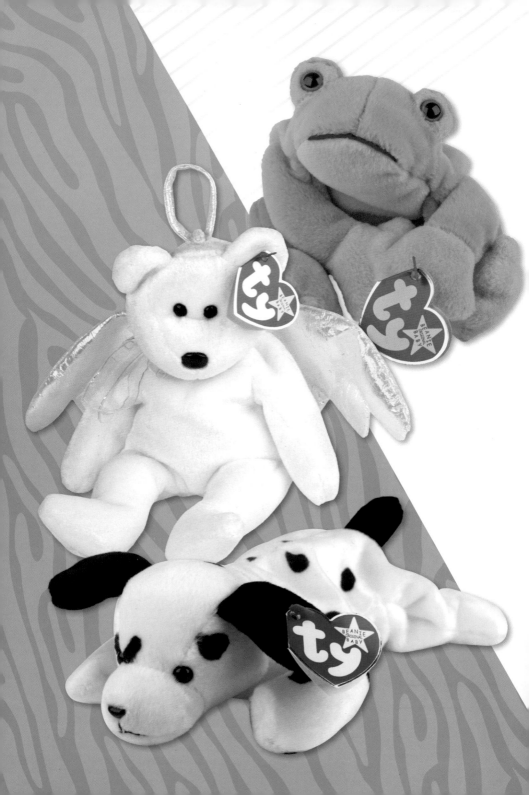

BEANIE BABIES

Were you tired of your old, overly stuffed plush toys? Did you want one that could lie limply in your hand and simultaneously skyrocket in value? Then Beanie Babies were the toy for you. Created by Ty Warner in 1993, the first Beanies (known as the "original nine" by collectors) were Flash the dolphin, Splash the whale, Squealer the pig, purple Patti the platypus, Legs the frog, Chocolate the moose, Spot the dog, Brownie the bear, and Pincher the lobster. But it wasn't until 1996 that people started coming down with the Beanie crazies.

From top: Smoochy the Frog, Halo the Angel Bear, and Dotty the Dalmatian, "born" in 1997, 1998, and 1996 respectively, all sporting their official heart-shaped hang tags.

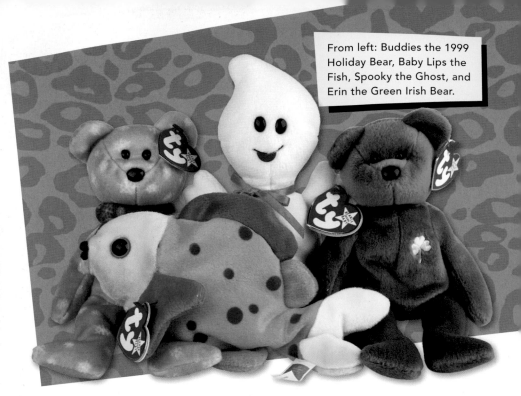

From left: Buddies the 1999 Holiday Bear, Baby Lips the Fish, Spooky the Ghost, and Erin the Green Irish Bear.

Initially I think what drew people to them was how cute they were. But the variety in the line was also impressive. If you'd always hoped to own a chameleon that was about eight inches long or a similarly sized bat, or a beaver, your dreams could come true in Beanie form. When you held one, its body just kind of flopped around. It almost felt like they were the product of a really apathetic manufacturer who'd run out of the fluff that was supposed to go inside of the stuffed animal and was just like, "Fill it halfway with pellets and sew that mother up! It's five o'clock, y'all. I'm out."

Every Beanie had a red heart "Ty" hang tag, which you weren't supposed to rip off for a couple of reasons. First, when you opened up the tag, it contained the Beanie's name and date of birth, in addition to a four-lined

Fleece the Lamb, born in 1996, now has a teenage angsty look about her.

poem (also known as a quatrain, as you'll remember from high school English) about your new friend. And then, if you were a serious collector, the tag needed to be intact if you wanted to maintain the Beanie's monetary value.

Some Beanies were worth more than the five bucks you'd paid for them. Fanatics kept track of how much each Beanie was worth by studying value and pricing guides. Beanies would be retired from time to time, so having a rare one, one that was no longer on the market,

Glory the Bear's tag astutely rhymed "Independence Day" with "USA" on July 4th, 1997.

brought up the value. The price range could be anywhere from a couple of dollars to hundreds. The original Brownie the Bear had its name changed to Cubbie, so if you have a Brownie, it's supposed to be worth more than $3,000 today. Misprints on the hang tags or other manufacturing errors also drove up prices. In my opinion, there were too many mistakes for it not to have been a calculated marketing scheme. This being said, the only person I know of who earned his fortune through Beanie Baby speculation is Ty Warner.

Beanie Babies could be special even if they weren't worth money, though. You could buy a Beanie for narcissistic reasons—because it had the same birthday as you—but there were also commemorative and graduation Beanies that you might want to buy for special occasions. You could put a Beanie on your bookcase to spruce things up a bit or you could use them as maracas and start a band. Really, the sky was the limit.

BOY TRENDS

Anything tight or even practical was nerdy during this time, and one of the reasons why Steve Urkel wasn't cool was because his clothes clung to his body. All he would have had to do was put on an oversized Starter jacket and turn his pants backward and Laura would have come swooning.

A Starter jacket, the ultimate cool-kid accessory, and a Kris Kross patch, which could have been stitched onto a backward shirt to demonstrate your love for the teen rap duo.

STARTER JACKETS

Starter jackets were puffy coats emblazoned with the name and colors of professional sports teams. You may or may not have been a fan of the team on your jacket—the trend was more about style than it was about sports. Though they were predominately worn by boys, they were popular with girls, as well. Really, anyone who wanted to look fresh was wearing one of these. Like, if the Fonz had been a character on a '90s sitcom, he would have worn a Starter jacket instead of a leather jacket.

There was a hip-hop/Starter jacket connection that upped the jackets' appeal with kids but made adults wary. There was also an article about Starter anorak jackets in one of my *Disney Adventures* magazines, which I think speaks to the proliferation of the trend. They were fairly expensive, and the store that sold Starter jackets in my area would display them high up on the walls so no one would steal them. They were so cool that warm weather wasn't going to deter anyone from wearing these heavy, oversized coats.

BACKWARD CLOTHES

Kid rappers Chris "Mac Daddy" Kelly and Chris "Daddy Mac" Smith of Kris Kross released instant hit "Jump" in 1992. The duo wore their clothes (mostly sports jerseys and baggy pants) backward, which started one of the most impractical fashion trends in history. I will say that the style didn't look as crazy on Kris Kross as it did on your average suburban kid. If you were in elementary school, you probably weren't going to have access to the oversized jeans and

The Kris Kross album cover reveals the ingenuity of wearing clothes backward . . . or not.

192

expensive baseball jerseys that the rappers did, so you were just going to be wearing your well-fitting striped T-shirt and jeans backward, which would have made any boy look crazy or like his parents were neglecting him.

NO FEAR

No Fear: when existentialism meets extreme sports in middle-class suburbia.

The No Fear clothing line was created in 1989, and the company's T-shirts were the cornerstone of every scrawny suburban boy's wardrobe by the mid-'90s. If you were wearing a No Fear T-shirt, then you were telling the world that you played hard, thought hard, and had no self-awareness—the shirts were corny, but boys were so emboldened by the logo's aggressive, testosterone-vetica font that they didn't notice. While some of the shirts were plain, save for the brand's extreme logo, others had slogans that read like a kind of CliffsNotes version of *Chicken Soup for the Macho Boy's Soul*. No Fear was selling pseudo-philosophy in shirt form and the slogans ran the gamut from things that youth basketball coaches say (you miss 100 percent of the shots you don't take) to bleak fortune cookie wisdom (he who dies with the most toys, still dies). You might wear your No Fear shirt during a soccer scrimmage to intimidate every-one that you came up against (your opponents would think, "Oh crap, this kid has no fear" and then run off crying in the opposite direction) or with a pair of jean shorts and a backward baseball cap if you were just chilling and wanted to look like the freshest guy in the world. By the end of the decade, boys began to realize that they did have some fear, and the brand fell out of favor.

DISNEY ANIMATED MOVIES

Snow White, *Cinderella*, *Pinocchio*, *Sleeping Beauty*—in the past, the most well-known Disney animated features were based on European fairy tales. But 1992's Aladdin borrowed from "One Thousand and One Nights," an Arabic folk story. *Lion King* (1994) was a take on Shakespeare's *Macbeth*, but it was set in Africa. The next year's *Pocahontas* was based on the life of the historical Native American woman's story. *Mulan*, released in 1998, has a Chinese girl as its protagonist. In the '90s, Disney sought diversity. All right, so some people found

Opening up a whole new world of home entertainment, *Aladdin* was released on VHS in 1993 and packaged in the obligatory white vinyl Disney clamshell case.

Aladdin racist, Native Americans said that Disney had glossed over how Pocahontas's tribe had really been treated by the English settlers, and the only film with Africa as its backdrop is about animals, so no black people were present. But it's clear what they were aiming for.

THE SOUNDTRACKS

Pop artists performed renditions of Disney movie themes and the songs became radio hits. "Beauty and the Beast," the theme song to the

1991 Burger King action figure of the Beast in his formal wear.

1991 movie, was performed by Celine Dion and Peabo Bryson and won two Grammys. The *Mulan* soundtrack included "Reflections" by a then little-known Christina Aguilera and "True to Your Heart," a duet performed by Stevie Wonder and 98 Degrees. Disney themes were interwoven into our lives. *Aladdin*'s "A Whole New World" and *The Lion King*'s "Can You Feel the Love Tonight" were preteen romance anthems and also featured prominently in elementary school recorder recitals. "Hakuna Matata" (which means no worries for the rest of your days), another *Lion King* ditty, was known by people of all ages, even those, I'm sure, who'd never seen the movie.

Vintage Aladdin digital wristwatch.

HAKUNA MATATA

POCAHONTAS

At the beginning of the decade it was a guarantee that each new Disney animated feature would be great. It was almost sad when the latest one came out because you knew that it would be a year or two before you'd get to see the next one. But then *Pocahontas* was released in 1995. It made a lot of money because we all went to see it, thinking that it would be as good as the movies that had come before it. But it wasn't. It was the only Disney movie that, up until that point, I saw only once (it was pretty common for kids to watch these movies on a loop). Really, they should have just released the theme "Colors of the Wind," sung by Vanessa Williams,

Burger King Pocahontas cup almost featuring a Disney kiss.

and scrapped the movie. On the other hand, I was twelve years old. So maybe that's the age that the Disney spell starts to wear off.

Newsies

Before Christian Bale was an Academy Award–winning actor/Batman/guy who yells at everybody, he was one ah dah newsies, carrying the banner for a penny a pape. *Newsies*, a 1992 Disney live-action musical, was about the newsboy strike of 1899. The movie didn't perform well at the box office when it was initially released, but has found a cult following over the years and recently was adapted for the Broadway stage. Most people believe *Citizen Kane* to be the most important movie about the newspaper industry, but they're wrong: it's actually *Newsies*. The best part of the musical: Christian Bale tries really hard to dance and is almost not totally horrible.

MIGHTY DUCKS

THE ANIMATED SERIES

Fridays, check local listings for time and channel
and watch Saturdays on ABC.

©Disney

THE MIGHTY DUCKS

The first Mighty Ducks movie, released by Walt Disney Pictures in
1992, found erstwhile brat-packer Emilio Estevez playing Gordon
Bombay, a lawyer who missed a penalty shot in a hockey game
when he was a preteen and, as a direct result, grew up to be a pomp-
ous jerk. One DUI later, Bombay is sentenced to five hundred hours of
coaching peewee hockey (that's something that happens in the world,
right?). The clumsy ragamuffins that he is saddled with included flatulent
goalie Goldberg, girl Connie, and Charlie, who is the sensitive moral
center of the group. Fulton, a gentle giant with the preternatural ability
to hit a puck so hard that it could tear through the back of a goal net,

A button advertising Disney's Mighty Ducks animated series. The
cartoon was inspired by the successful Mighty Ducks film trilogy.

and "cake eater" Adam Banks, a star player who had to leave his first-place team because of redistricting, are later added to the roster. In time, Bombay molded the team into a force to be reckoned with, as the kids molded him into a person with a soul, and the District 5 no-names became the Mighty Ducks.

KEEP ON QUACKIN' IN THE FREE WORLD: THE STORY CONTINUES

The Mighty Ducks was such a success for Disney that two sequels followed. In the first, D2: The Mighty Ducks, Bombay and the team were drafted to represent the USA in the Junior Goodwill Games (and that was 100% plausible because they had won that one regional peewee hockey championship two years earlier). The Ducks did pick up a handful of new players, though, counting Tiger Beat heartthrob Mike Vitar and All That's Kenan Thompson (who teaches them how to play "schoolyard puck" in the 'hood) as new members of the flock. In the final movie of the trilogy, D3: The Mighty Ducks, the Ducks—with the new kids that they'd picked up as Team USA in tow—are awarded scholarships to a prestigious private high school to play junior varsity hockey.

In an unprecedented move by Disney, the Mighty Ducks of Anaheim, an NHL team, were formed in 1993 (though they're no longer under Disney ownership and are now simply the Anaheim Ducks). Mighty Ducks, an animated TV series about alien, hockey-playing ducks, aired in 1997. The cartoon really had nothing to do with the movies' storylines, but I think its creation was evidence of how bankable the Mighty Ducks idea had become.

McDonald's Happy Meal toy puck of the cartoon's goalie, Wildwing Flashblade, 1997.

WHEN EVERYONE SAYS IT CAN'T BE DONE, DUCKS FLY TOGETHER

The Mighty Ducks introduced phrases like "triple deke" and "knuckle puck" (two hockey maneuvers used by characters in the movies), into the lexicon, but it also introduced a new generation to the sports movie tropes that we'd see repeated (and occasionally deconstructed) as we got older. One of those tropes, of course, being that the underdogs, through sheer scrappiness, should always beat a more talented team—all three movies follow the same formula and end with the Ducks facing off against a team that should beat them but doesn't because they aren't virtuous or scruffy. Having a lot of heart doesn't guarantee victory. But what if it did?

When you're young, you don't get bogged down in thinking about how cliché something is. Good triumphs over evil here; the team with the odds stacked up against them comes out on top. Maybe that's not realistic, but when you're a kid, it gives you hope, and sometimes that's more important.

Because ducks, as a species, are evidently known for their solidarity and plucky determination, the name emblazoned across the kids' jerseys grew to symbolize their perseverance and teamwork—ducks fly together, after all. With "Quack, quack, quack" as their rallying cry, they Flying V-ed their way into championship victories and our hearts.

But I'd still like to know what the hell a "cake eater" is.

The Sandlot

This 1993 coming-of-age comedy was about a group of boys in the '60s who play baseball every day in an abandoned lot until they lose their ball—signed by "the Great Bambinooooo"—to a "giant gorilla dog thing that ate one kid already." *The Sandlot*, which gave us a slew of memorable lines ("You're killing me, Smalls" and "for-ev-er"), felt like a classic as soon as it was released. Even if you weren't into baseball, the movie was about friendship, fitting in, and the magic of summer—and those things are universal.

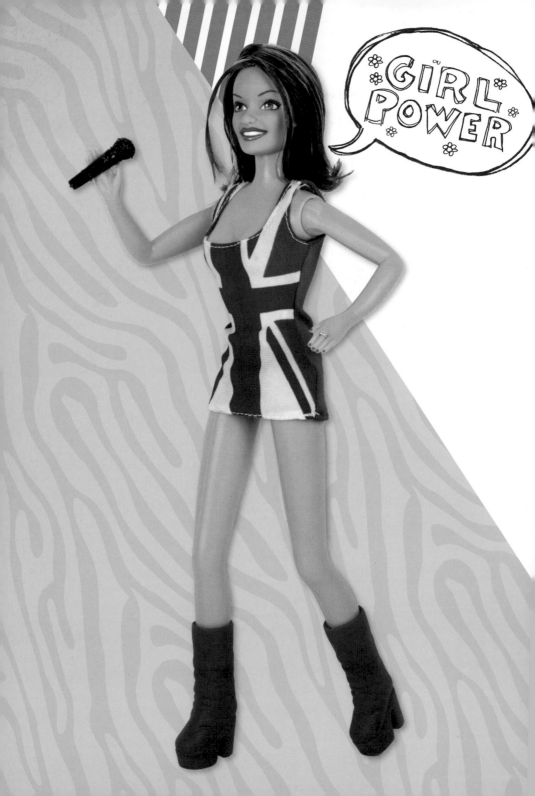

SPICE GIRLS

The Spice Girls were a lot like the Beatles in that they were both British music acts with hordes of screaming, crying fans. But the Spice Girls were savvier than the "Fab Four" because they were able to achieve superstardom that was based almost entirely on persona as opposed to talent. Baby Spice was the innocent blond one who wore her hair in pigtails. In group photos, she was normally hunched over, knees together, as if she were holding in her pee (underscoring her babyness because babies have no bladder control). Sporty Spice had a gold tooth. Also, she may have been into sports. Ginger Spice had red hair and wore hot pants that her crotch was determined to eat. Posh Spice couldn't sing or dance but was allowed to stand next to the girls

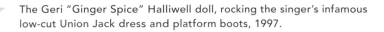

The Geri "Ginger Spice" Halliwell doll, rocking the singer's infamous low-cut Union Jack dress and platform boots, 1997.

anyway. And Scary Spice had the best abs of the group and a mane of curly hair. Oh, and she was black, so naturally she performed the rap verse in their first single. When the music world was flooded with boy bands, the Spice Girls stood for, as they put it, "girl pow-uh" (or "girl power," to the layperson), and in 1996, what we wanted, what we really, really wanted, was them.

SPICE UP YOUR LIFE

Emma Bunton, Melanie Chisholm, Geri Halliwell, Victoria Adams, and Melanie Brown were brought together through an open audition for an all-female pop group in 1993. They took on their new spicy monikers and three years later their first single "Wannabe" was released. The song was upbeat, catchy, and seemed to be endorsing polyamory ("If you wanna be my lover, you gotta get with my friends").

Alternative lifestyles aside, "Wannabe" had the highest debut on the pop charts by a British group since the Beatles' "I Want to Hold Your Hand" and marked the first appearance of the term "zig-a-zig-ah." Though a bit strange, this zig-a-zig-ah business, I think, showed that the Spice Girls didn't take themselves too seriously—they were the embodiment of what Cyndi Lauper was talking about in "Girls Just Want to Have Fun." In the "Wannabe" music video, they hopped around a lot and young girls watching them were entranced by that energy.

"Wannabe" was followed by a string of hit singles that addressed the important issues of the day. "Say You'll Be There" was about being there and "Spice Up Your Life" was

A saucy Spice Girls T-shirt.

about spicing up your life. A year after their
debut, *Spice World* brought the girls to the
big screen, and the movie was lauded
by the always ruthlessly discerning tween
demographic.

SPICE GIRLS DOLLS

Their spice nicknames practically turned the
group into living dolls—Barbie came in different
models and so did Spice Girls—so Galoob's 1997 doll
line was inevitable. In total, nine different collections
were released. The dolls featured in the first "Girl Power"
collection were eleven inches tall, and all had the same
slender body. The Geri "Ginger Spice" Halliwell doll came
with a video camera because I guess filming things while
wearing a really short Union Jack dress was one of her
hobbies. My favorite is the Sporty Spice doll because,
with her trademark gold crown, it looks like she has
spinach stuck in her teeth.

FRIENDSHIP NEVER ENDS

The girlfriends that I had in middle school bonded over a shared love of
the Spice Girls and assigned one another Spice names. At first we borrowed
the names of the singers (there was some controversy over which Spice Girl
I should be because I was sporty but also black like Scary), but then we just
came up with our own (Smart Spice, Vietnamese Spice, that sort of thing).
The Spice Girls were all about friendship. They were also positivity personi-
fied. I realize that they wore bras as tops, but sometimes that's what positivity
looks like.

Mel C, aka
Sporty Spice,
and her "gold"
tooth, 1997.

205

ACKNOWLEDGMENTS

I'd like to thank my grandmother and family for their boundless enthusiasm; Lancey, whose input was indispensable; and Susie, best friend extraordinaire. Thanks to Stephen Beachy; the faculty of the MFA program at the University of San Francisco; William Yokoyama; and my third grade teacher, Mrs. Tracy Allegrotti. Infinite high fives to Sally, everyone at Rookie, anyone who reads my blog *nostomanic*, Claudia, and all of the kids I grew up with. Thank you, Kjersti, becker&mayer!, Abrams, and everyone who had a hand in making this book a thing that actually exists. I also obviously owe a tremendous debt of gratitude to Freddy Krueger and that troll from the 1985 movie *Cat's Eye* for leaving me alone whenever I've been by myself in the dark. Finally, thanks to Grandad, who I miss terribly, and my selfless, wonderful, supportive mom, who gave me the ultimate childhood, filled with pogs and love.

ABOUT THE AUTHOR

Amber Humphrey writes about pop culture for Rookie, a website for teen girls. She lives outside San Francisco and has too many cats.

The products and objects found in this book were collected and photographed by becker&mayer! The product creators and respective trademark holders did not authorize this book and did not furnish or approve any of the information contained therein. Every effort has been made to ensure that the credits and trademarks accurately comply with the information supplied. If a credit has been omitted or stated incorrectly, becker&mayer! would be pleased to make corrections in future editions.

TRADEMARKS

Cover: *Captain Planet and the Planeteers* is a registered trademark of TBS Productions, Inc.; POG is a registered trademark of POG Unlimited; Reebok is a registered trademark of Reebok International Ltd. Back Cover: *The Oregon Trail* is a registered trademark of HMH Consumer Co.; Tiger Electronics is a registered trademark of Hasbro, Inc. Pages 8–11: Super Soaker is a registered trademark of Larami Limited Corp.; Pages 12–15: Nickelodeon is a registered trademark of Viacom International, Inc.; Page 14: *The Ren & Stimpy Show* is a trademark of Viacom International, Inc.; Pages 16–21: Rollerblade is a registered trademark of Rollerblade, Inc.; Page 18: Nintendo is a registered trademark of Nintendo of America, Inc.; Pages 22–25: Bart Simpson and *The Simpsons* are registered trademarks of Twentieth Century Fox Film Corp.; Pages 26–29: Batman and Catwoman are registered trademarks of DC Comics; Page 37: Ecto Cooler is a registered trademark of the Coca–Cola Company; Page 37: *Back To The Future* is a registered trademark of Universal Pictures; Pages 38–42: Goosebumps is a registered trademark of Scholastic, Inc.; Pages 44–47: *Beakman's World* is a registered trademark of ELP Communications; Pages 48–54: *Captain Planet and the Planeteers* is a registered trademark of TBS Productions, Inc.; Pages 56–60: *Where in the World is Carmen Sandiego* is a registered trademark of HMH Consumer Co.; Pages 60–61: *The Oregon Trail* is a registered trademark of HMH Consumer Co.; Pages 62–67: Tiger Electronics is a registered trademark of Hasbro, Inc.; Page 62: WCW is a registered trademark of WCW, Inc.; The Mighty Morphin Power Rangers is a registered trademark of SCG Power Rangers LLC; Page 64: Batman & Robin is a registered trademark of DC Comics; Page 64: *Jurassic Park* is a registered trademark of Universal City Studios LLC, and Amblin Entertainment, Inc.; Pages 67–71: Disney is a registered trademark of Disney Enterprises, Inc.; Page 67: *Tale Spin, Ducktales*, and *Darkwing Duck* are registered trademarks of Disney Enterprises, Inc.; Pages 68–69: Goofy is a registered trademark of Disney Enterprises, Inc.; Pages 70–77: POG is a registered trademark of POG Unlimited; Page 78: Hammer Slammer is a registered trademark of B and P Plastics; Page 75: *Magic: The Gathering* is a registered trademark of Wizards of the Coast LLC; Page 78–81: Lisa Frank is a registered trademark of Lisa Frank, Inc.; Page 78: Casey and Markie are registered trademarks of Lisa Frank, Inc.; Page 80: Roary is a registered trademark of Lisa Frank, Inc.; Page 81: Sanrio and Hello Kitty are registered trademarks of Sanrio Company Ltd.; Page 87: *Clueless* is a registered trademark of Paramount Pictures Corp.; Pages 88–91: Furby is a registered trademark of Hasbro, Inc.; Pages 92–99: The Mighty Morphin Power Rangers are a registered trademark of SCG Power Rangers LLC; Pages 100–103: Tamagotchi is a registered trademark of Kabushiki Kaisha Bandai; Pages 104–109: Teenage Mutant Ninja Turtles are a registered trademark of Viacom International, Inc.; Pages 114–117: *Home Alone* is a registered trademark of Twentieth Century Fox Film Corp.; Pages 118–121: Power Wheels is a registered trademark of Mattel, Inc.; Page 118: Barbie is a registered trademark of Mattel, Inc.; Page 118: Jeep is a registered trademark of Chrysler Group LLC; Page 120: Mercedes–Benz is a registered trademark of Daimler AG; Pages 122, 125: Nintendo, Super Nintendo Entertainment System, and Game Boy are registered trademarks of Nintendo of America, Inc.; Pages 122, 124, 125: Sega, *ToeJam and Earl*, and Game Gear are registered trademarks of Kabushiki Kaisha Sega; Pages 126–130: *Saved by the Bell* is a registered trademark of NBC Universal Media LLC; Pages 132–136: New Kids on the Block and NKOTB are registered trademarks of NKOTB, Inc.; Page 136: Hanson is a registered trademark of Hansonopoly, Inc.; Page 137: Backstreet Boys is a registered trademark of BSB Entertainment, Inc.; Page 137: 'NSync is a registered trademark of Zeeks, Inc.; Pages 138–140: Magic Eye is a registered trademark of Magic Eye, Inc.; Pages 142–145: The Chicago Bulls is a trademark of Chicago Professional Sports Limited Partnership; Page 145: *Space Jam* is a registered trademark of Warner Bros. Entertainment, Inc.; Page 146: SkipIt is a registered trademark of Hasbro, Inc.; Page 149: Bop It is a registered trademark of Hasbro, Inc.; Page 150: Reebok is a registered trademark of Reebok International Ltd.; Page 152: L.A. Gear and L.A. Lights are registered trademarks of L.A. Gear, Inc.; Pages 160–162: Green Day is a registered trademark of Green Day, Inc.; Page 163: The

Presidents of the United States of America is a registered trademark of The Presidents of the United States of America; Pages 164–171: TGIF is a registered trademark of American Broadcasting Companies, Inc.; Pages 172–176: Jurassic Park is a registered trademark of Universal City Studios LLC, and Amblin Entertainment, Inc.; Page 177: Barney is a registered trademark of Lyons Partnership L.P.; Pages 178–180: Tiny Toon Adventures is a registered trademark of Warner Bros. Entertainment, Inc.; Page 181: Animaniacs and Pinky and the Brain are registered trademarks of Warner Bros. Entertainment, Inc.; Pages 182–185: Sky Dancers are a registered trademark of Abrams Gentile Entertainment, Inc.; Pages 186–189: Beanie Babies are a registered trademark of Ty, Inc.; Page 190: Starter is a registered trademark of Studio IP Holdings LLC; Page 191, 193: No Fear is a registered trademark of No Fear International Ltd.; Pages 194–197: Disney is a registered trademark of Disney Enterprises, Inc.; Pages 201–205: Spice Girls is a registered trademark of Spice Girls Ltd.

IMAGE CREDITS

Illustrations by Jessica Eskelsen

Editor: Kjersti Egerdahl
Designer: Sarah Baynes
Photo Researcher: Jessica Eskelsen
Production: Tom Miller
Managing Editor: Michael del Rosario

Cataloging-in-Publication Data has been applied for
and may be obtained from the Library of Congress.
ISBN: 978-1-4197-0678-3

Did I Do That? is produced by becker&mayer!, Bellevue, Washington.
www.beckermayer.com
Printed and bound in China.
10 9 8 7 6 5 4 3 2 1

Abrams Image books are available at special discounts when purchased in quantity for
premiums and promotions as well as fundraising or educational use. Special editions can
also be created to specification. For details, contact specialsales@abrams.com or the
address below.

A

THE